emma kham
flaminio gundy
lawrence stock

MALTA

The island of the red hot colors

MALTA
The island of the red hot colors

by Emma Kham - Flaminio Gundy - Lawrence Stock

All rights reserved.
No part of this book may be used or reproduced in any manner without written permission of the publishers.

Copyright © 2016 by Emma Kham - Flaminio Gundy - Lawrence Stock

Createspace Independent Publishing, Charleston, South Carolina, USA, 2018

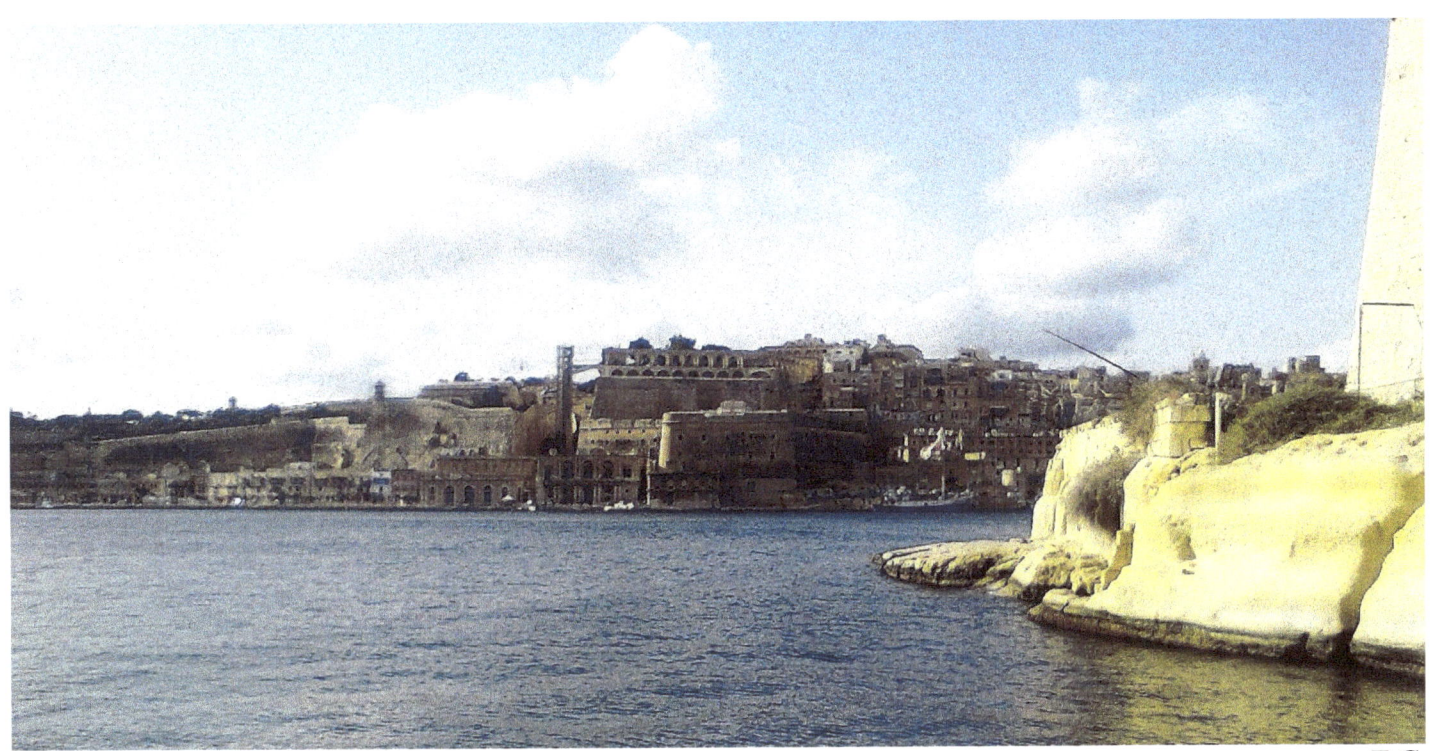
La Valletta *F.G.*

Prinjolata, cake prepared during Carnival. It is a sponge cake in the shape of dome, made with almonds, cookies, flavored with citrus cream, pine nuts and decorated with melted chocolate and cherries. First whisk the butter and sugar until the mixture becomes a smooth cream. Beat the egg whites in a bowl (placed in a bath of hot water) and continue to beat them adding the remaining sugar, half cup water and vanilla essence and mix well. Remove from heat and let cool. Now pour the butter cream and crushed pine nuts. Mix well. Grease a pudding mold and start the layering alternately upwards with Madeira cake slices and the creamy mixture until the completion of the cream. Leave the Prinjolata cake in the fridge overnight. Turn the Prinjolata very carefully from the mold and place on a dish. Cover it with frosting, pine nuts, chocolate chips and cherries. Put it in the refrigerator and let it cool for about 5 hours before serving.

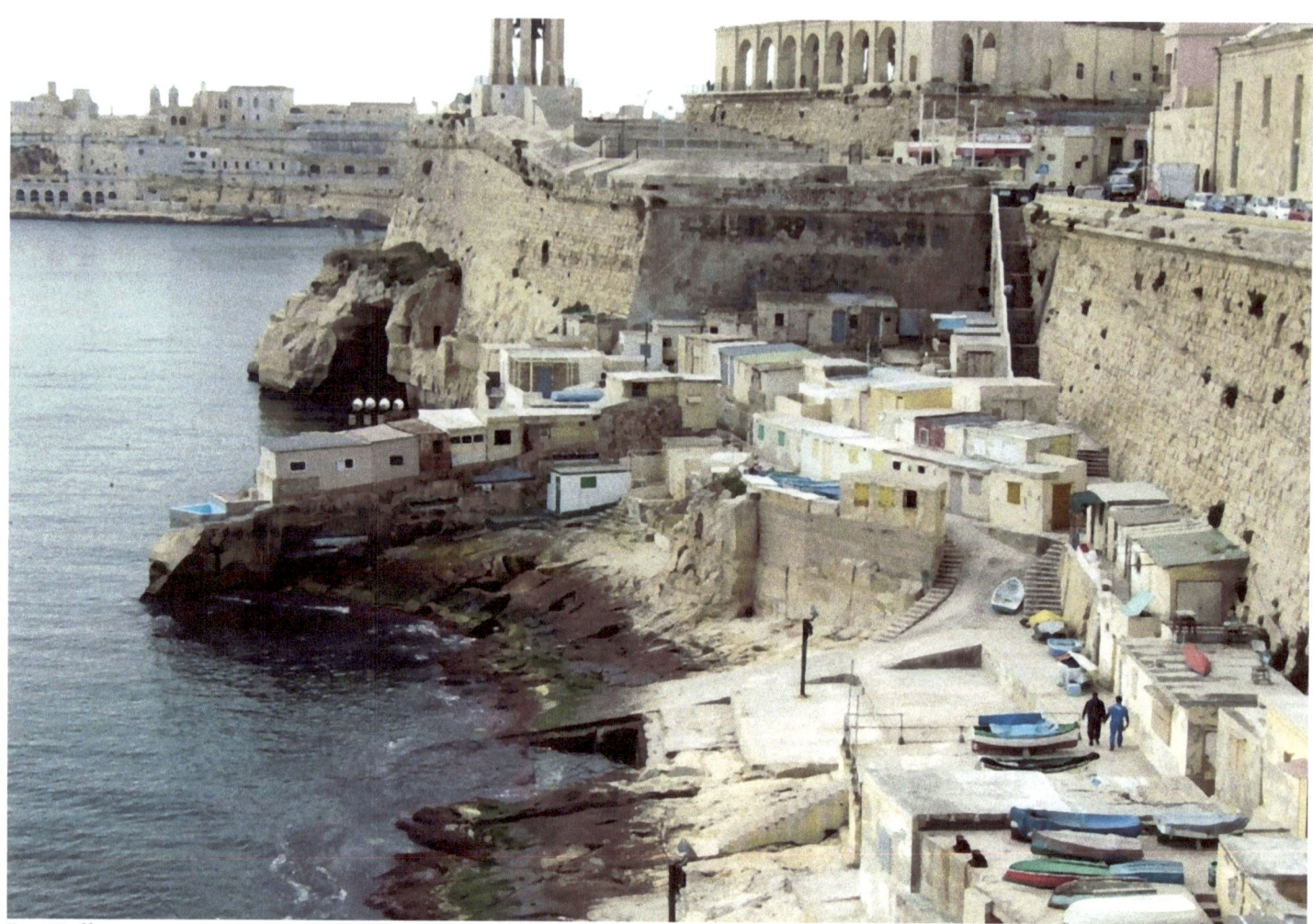
La Valletta F.G.

Fritturi Tal-Qargha Hamra, delicious and tasty appetizer with fried pumpkin served in Malta in autumn flavored with fresh herbs like sage and thyme. In one bowl place the beaten eggs, sage, thyme and seasoning. In another bowl add the flour. Take a piece of pumpkin, dip into the egg and then place into the flour. Fry on medium heat in olive oil for five minutes on each side. Serve warm as an appetizer or as a side dish.

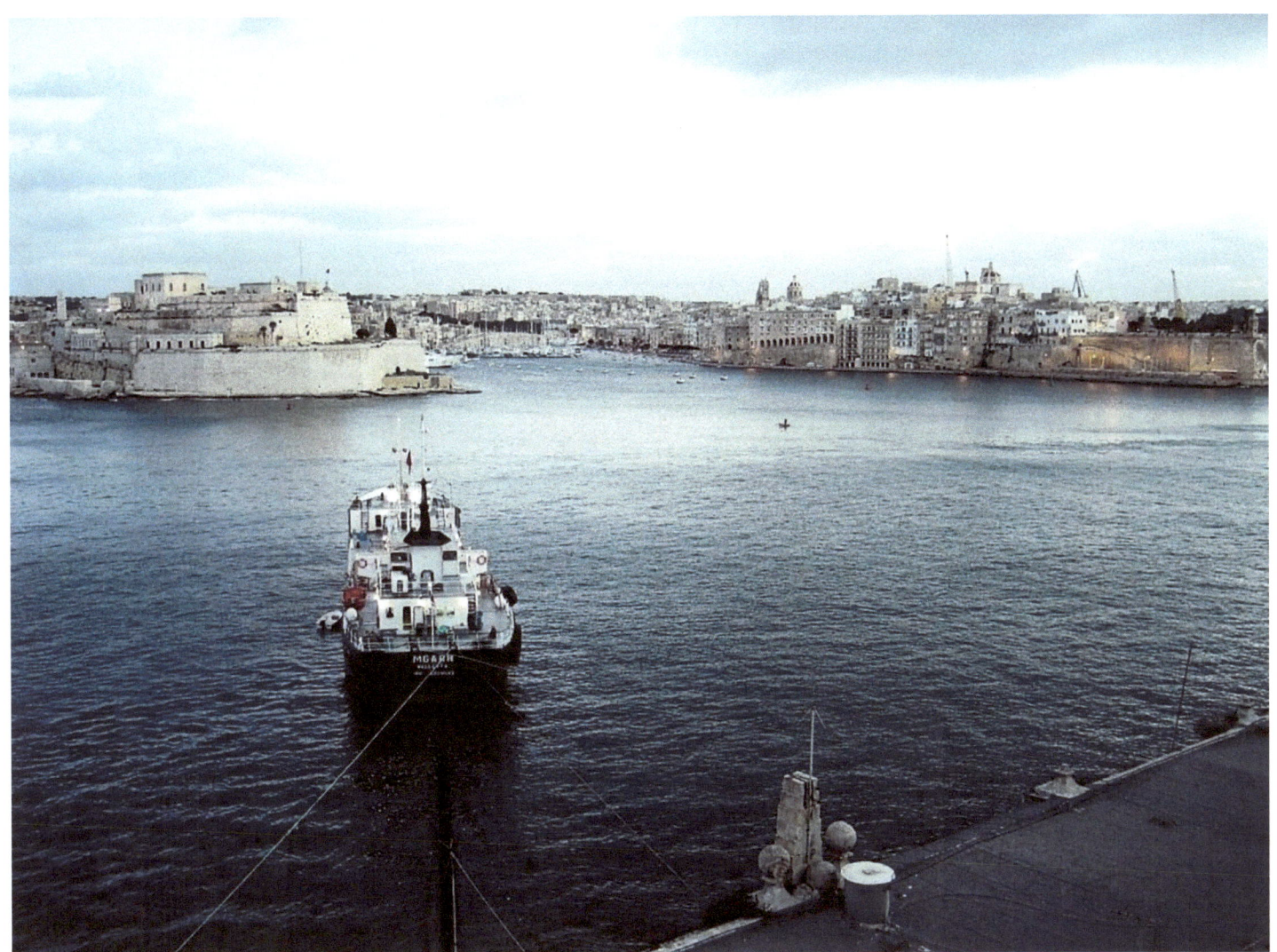

Vittoriosa and Senglea — *F.G.*

Gbejniet, goat cheese balls. They are small cheeses obtained from goat milk and are found in two varieties, one classic and fresh and one dried white version or with pepper, where the cheese is flavored with much black pepper and then dried.

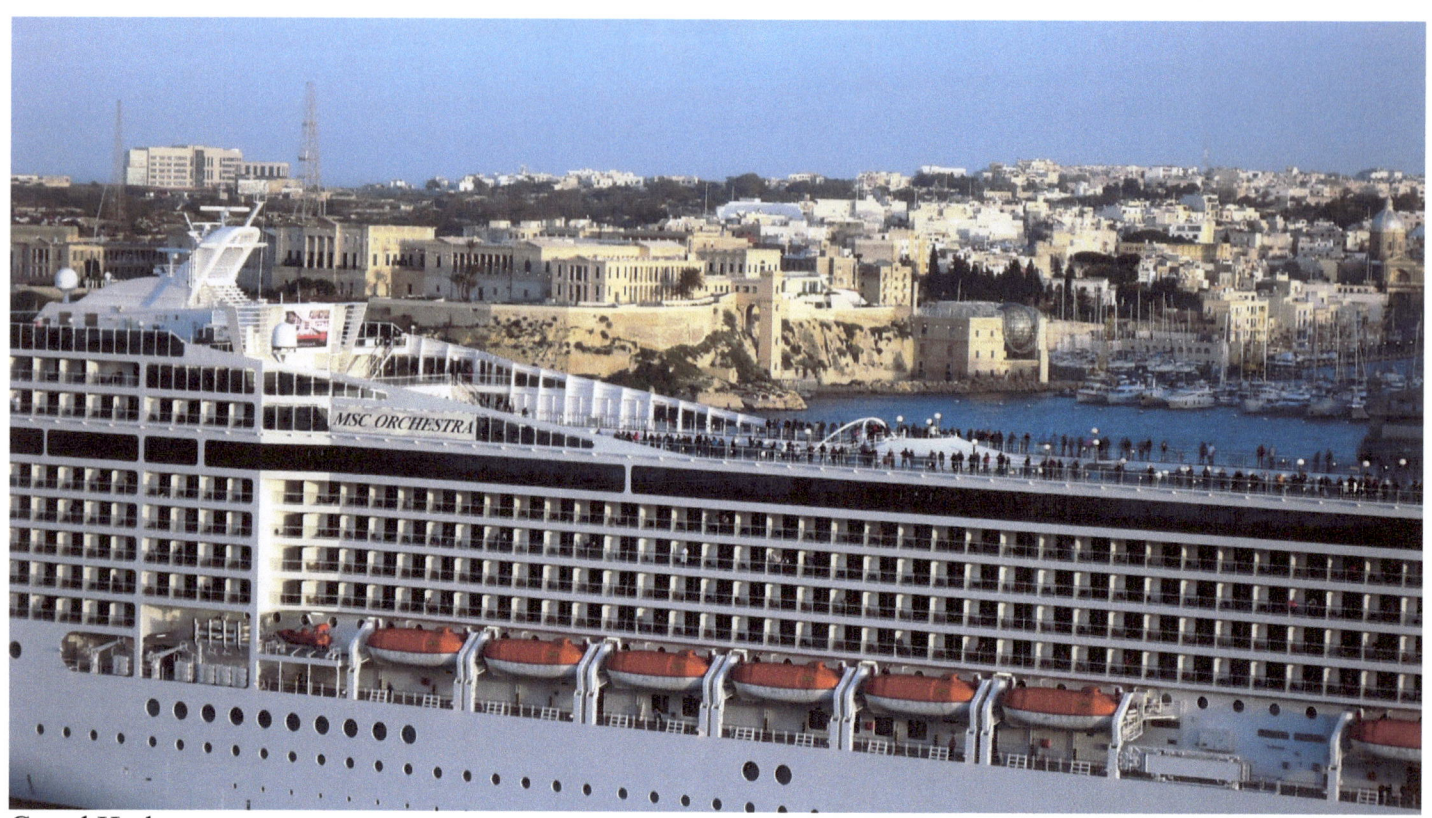

Grand Harbour *F.G.*

Timpana, macaroni pie baked stuffed with meat and boiled eggs. Make a ragout with onion, garlic, beef and pork, chicken livers, tomato paste, salt and pepper, olive oil and a bit of water or broth. When the ragout is ready add pasta, ricotta, beaten eggs and Parmesan. Line a greased and floured baking pan with a layer of puff pastry, pour the mixture into the pan and cover with another layer of puff pastry sealing well. Brush with beaten egg yolk. Bake at 180 degrees for about 50 minutes.

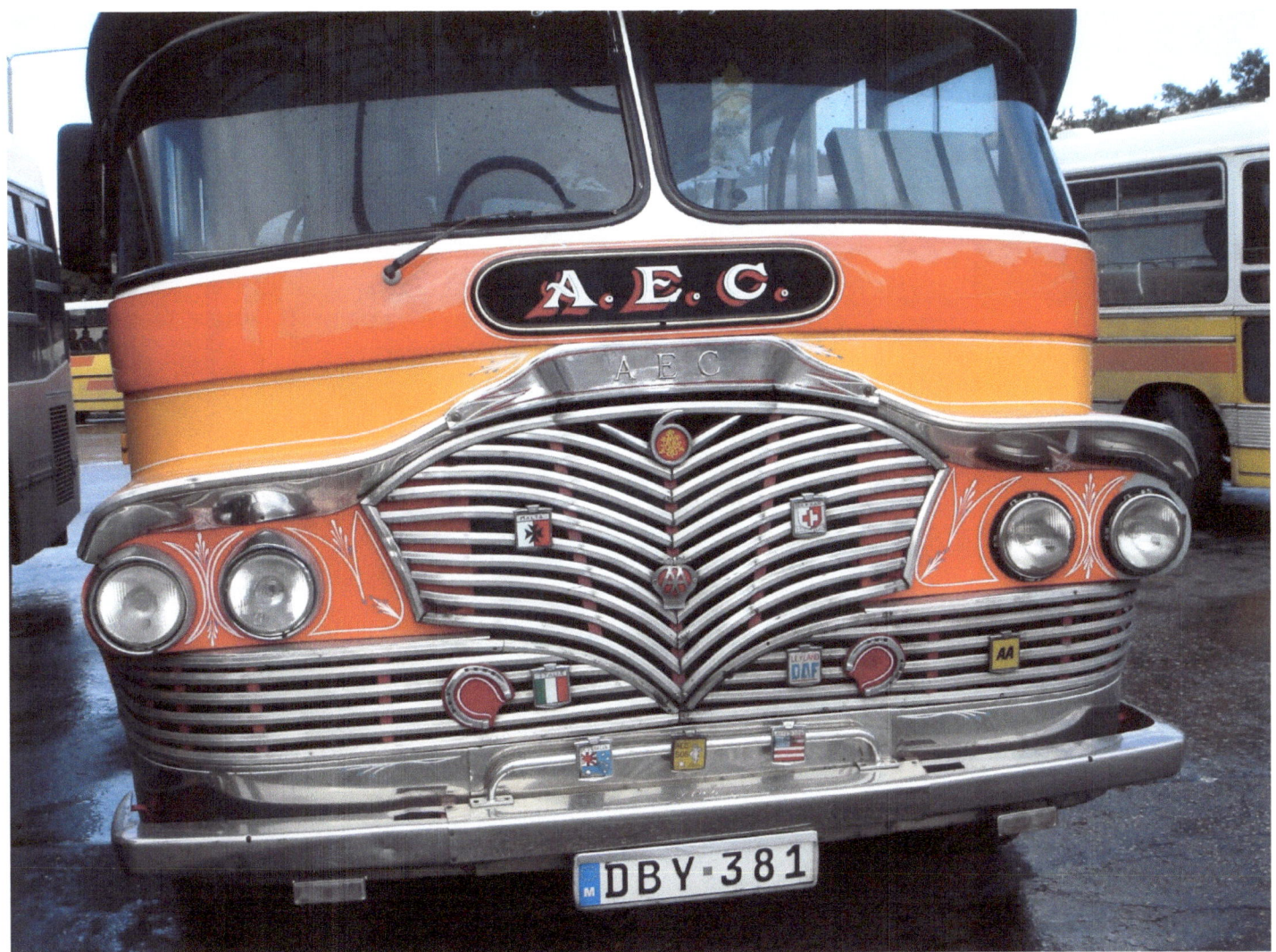

La Valletta L.S.

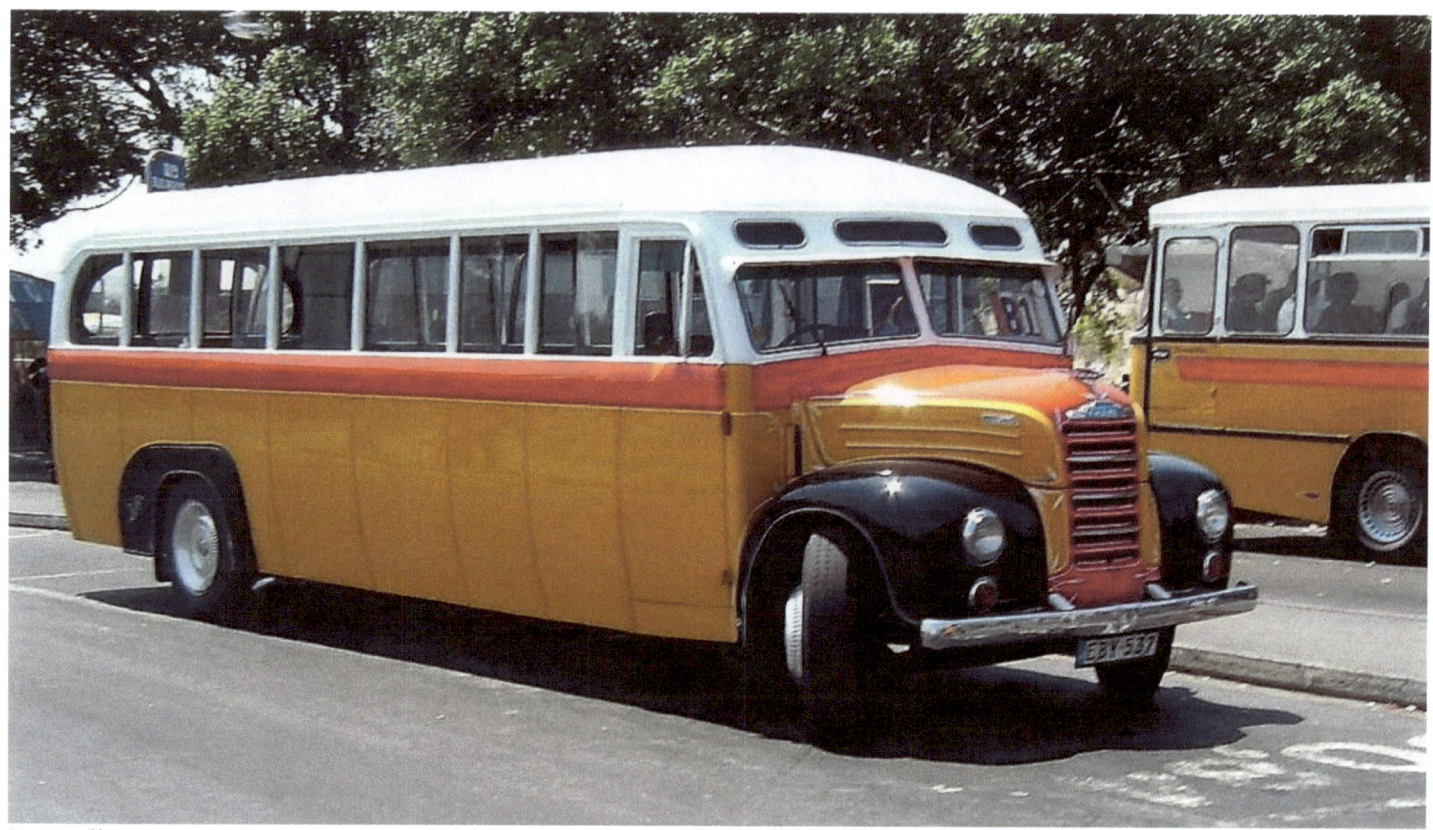

La Valletta *F.G.*

Qassatat, snacks of puff pastry filled with ricotta or peas. Sift the ricotta and chop with the blender the Parmesan and scamorza. Cut circles of 15 cm diameter from the sheet of shortcrust pastry. Beat the egg and hold a little aside, mix well the rest with the three cheeses of before and salt. Put a spoon of mixture in the center of each circle, moisten the perimeter of it with the tips of your fingers and make the folds around until to close like a container. Filled well with the rest of ricotta pressing a bit. Brush the dough with the egg put aside and bake at 200 degrees for about 20 minutes or until golden.

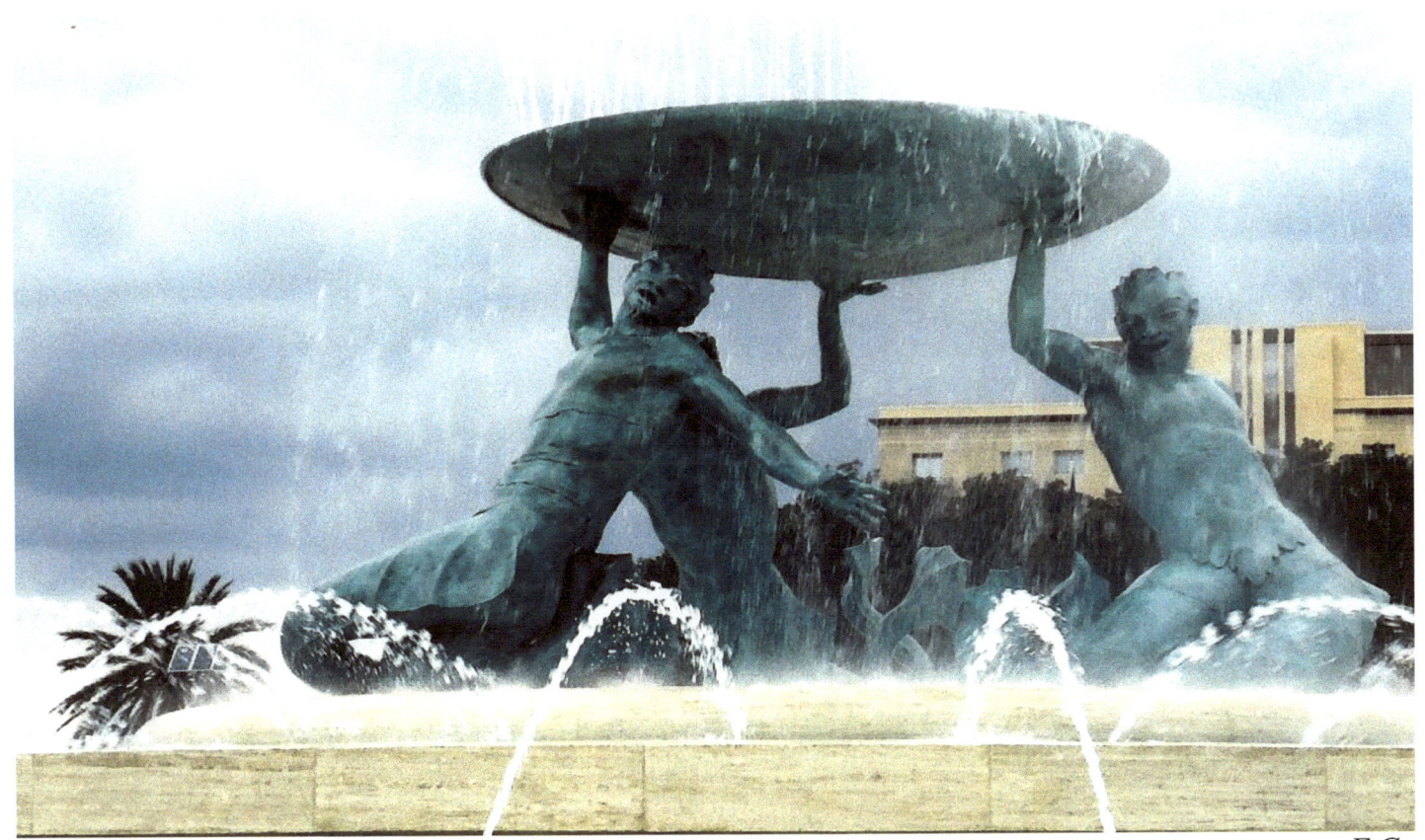
La VallettaF.G.

Figolli, biscuits stuffed with almonds. To make the dough, mix the flour with the sugar, then rub in the butter until the mixture looks like fine crumbs. Add the egg yolks and lemon zest, then sprinkle a bit of water to obtain a workable paste and let the mixture stand. Add the lemon zest and orange-flower water to the almonds and tie everything with the egg whites. Roll out the dough and cut out the shapes you want. Cut two shapes for each figolla, because they will be interspersed with almond paste. Lay the first form on a floured and greased baking sheet, sprinkle it with the almond paste, leaving a small margin. Put the second form on the previous one and press the edges together. Better wetting the edges with a pastry brush in order to ensure the ligation. Bake at 200 degrees for five minutes and then at 180 for another 20 minutes. Let cool on the tray.

La Valletta — L.S.

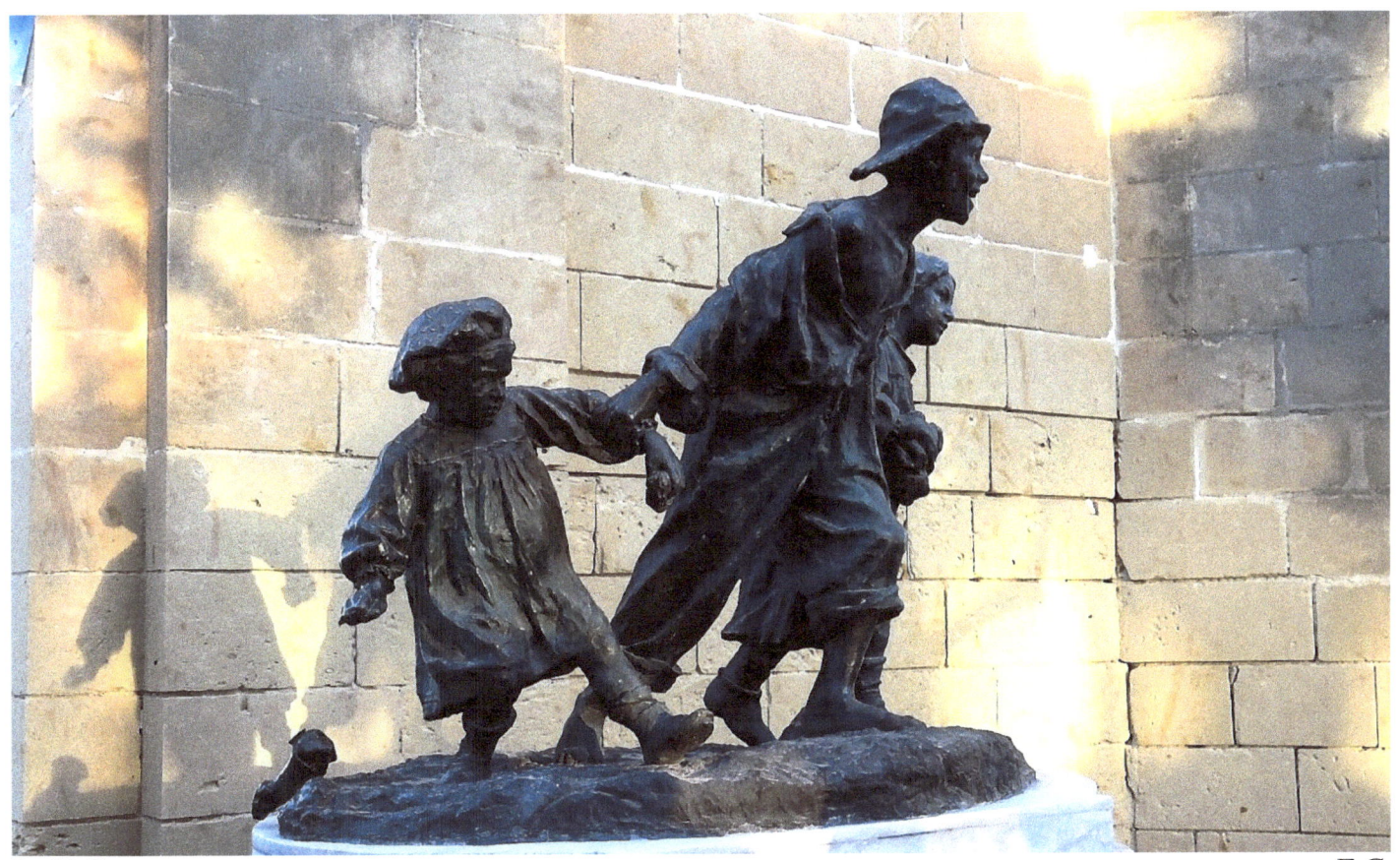

La Valletta F.G.

Soppa this Qarabaghli, very widespread zucchini soup. Take a fried onion, garlic and fresh mint, add the pieces of potato and zucchini, then the beans and peas. Pour the broth until to barely cover the vegetables. Simmer for about 30 minutes then chop everything with a hand blender. Add the parsley and mint leaves. Grate the cheese on each dish and pour the hot soup. Serve the soup with a bit of fresh cream on the surface.

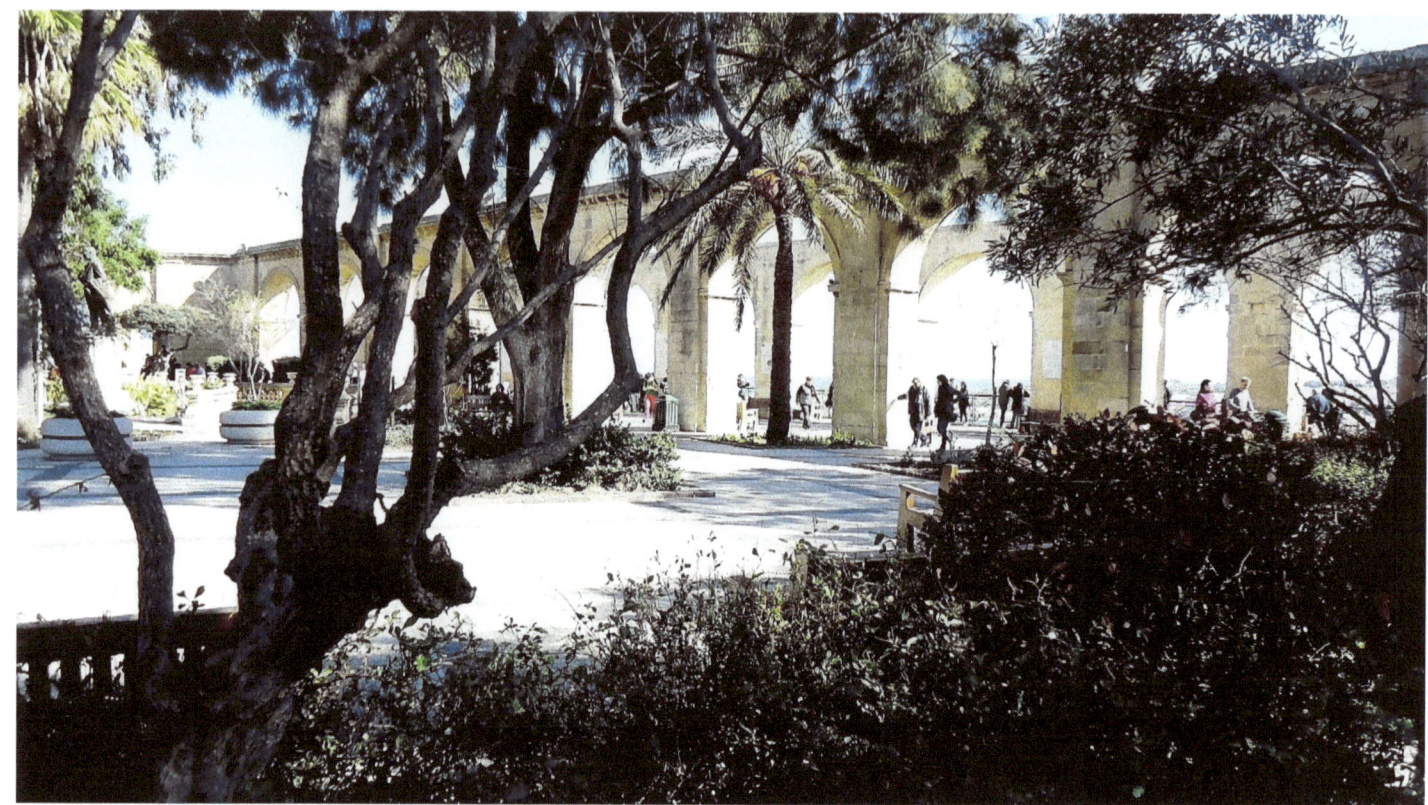

La Valletta *F.G.*

Soppa tal-Armla, saute garlic, onion and parsley in the butter and olive oil until soft. Add potato, carrot, kohlrabi, broad beans, celery, peas and cauliflower. Pour the chicken broth and tomato paste. Stir well and season to taste with salt and pepper. Bring to the boil, cover and simmer for about 20 minutes, until the vegetables are just cooked. Add gbejniet and press down lightly to submerge. Cover and cook for a couple of minutes to heat cheese. Garnish with parsley and still stir. Serve with one piece of gbejniet in each bowl.

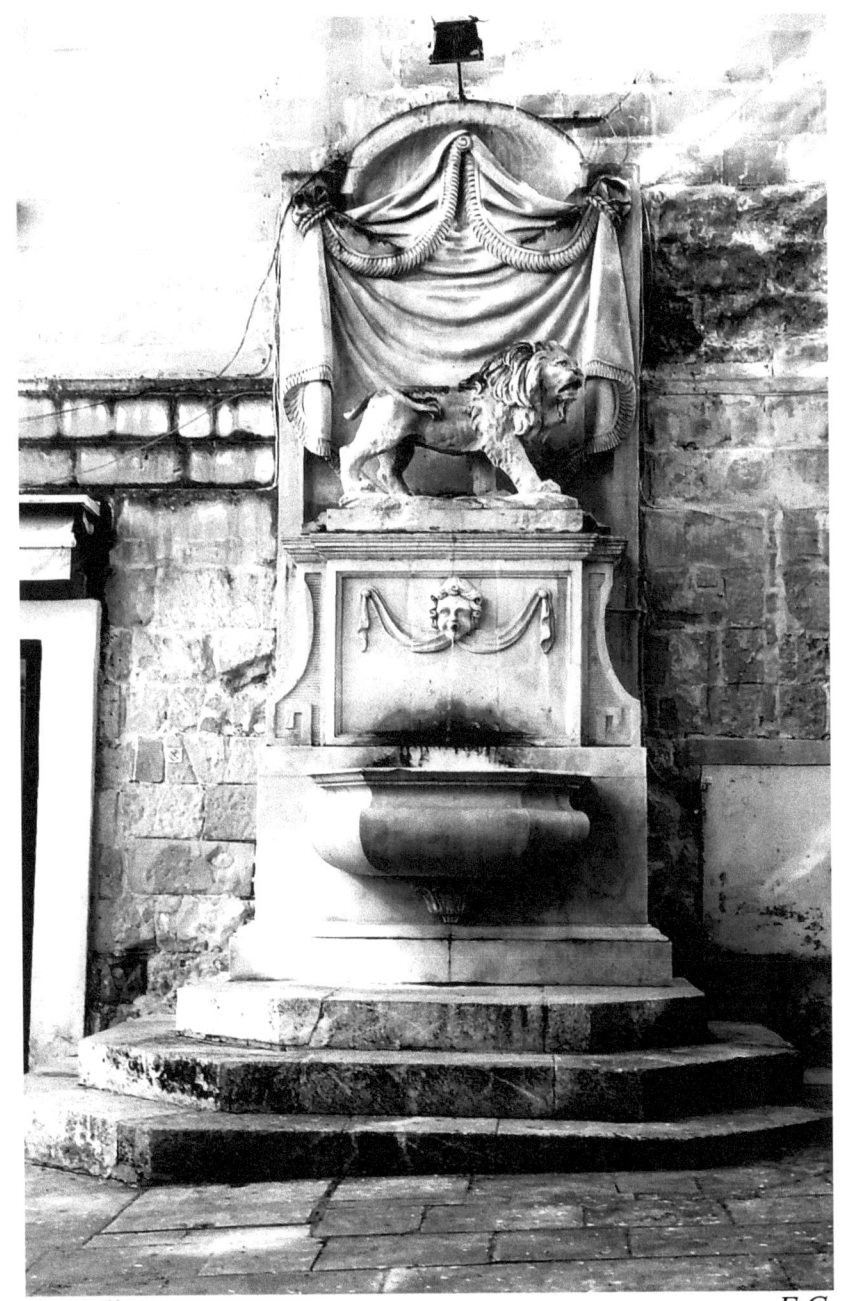

La Valletta F.G.

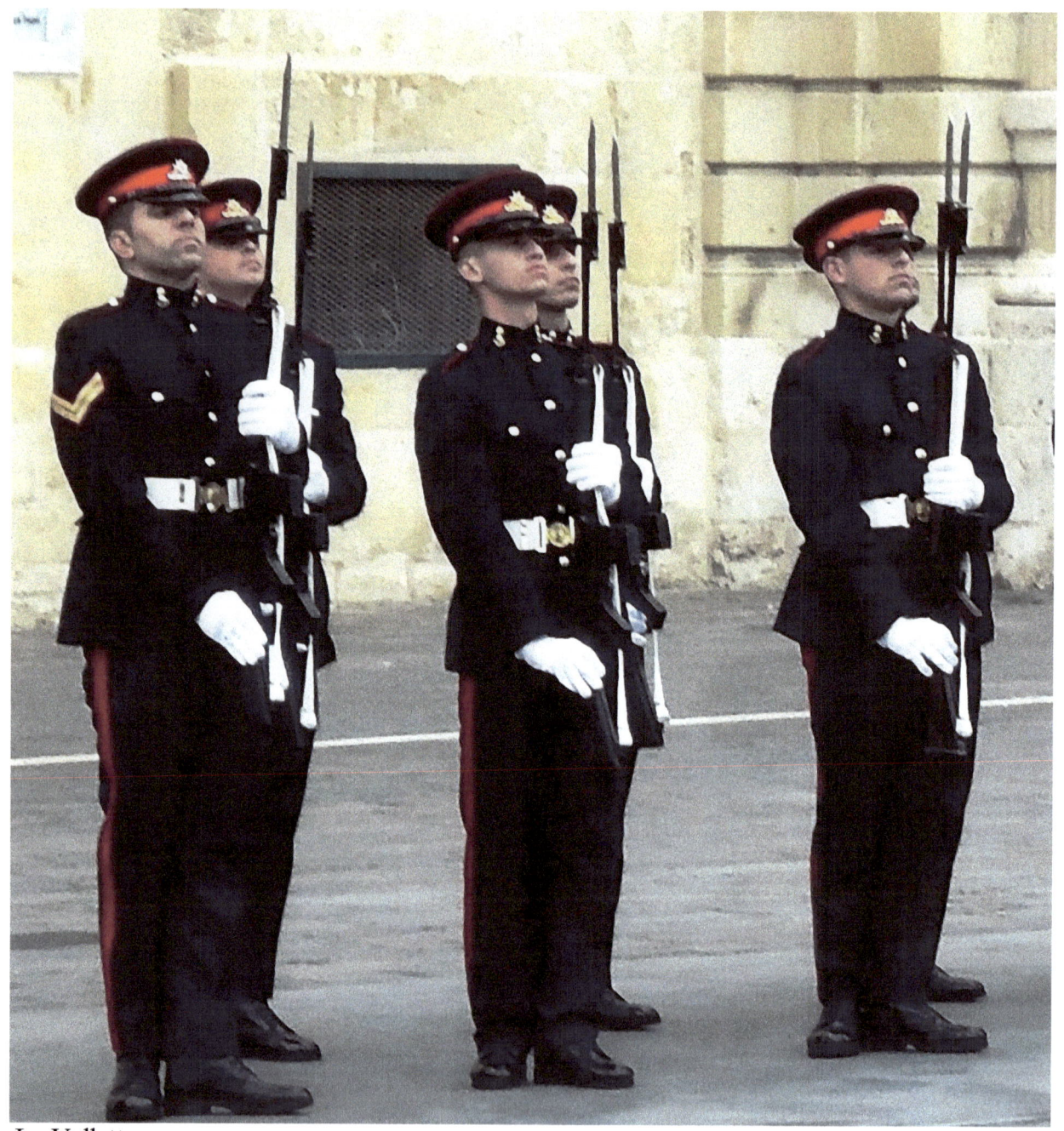

La Valletta *F.G.*

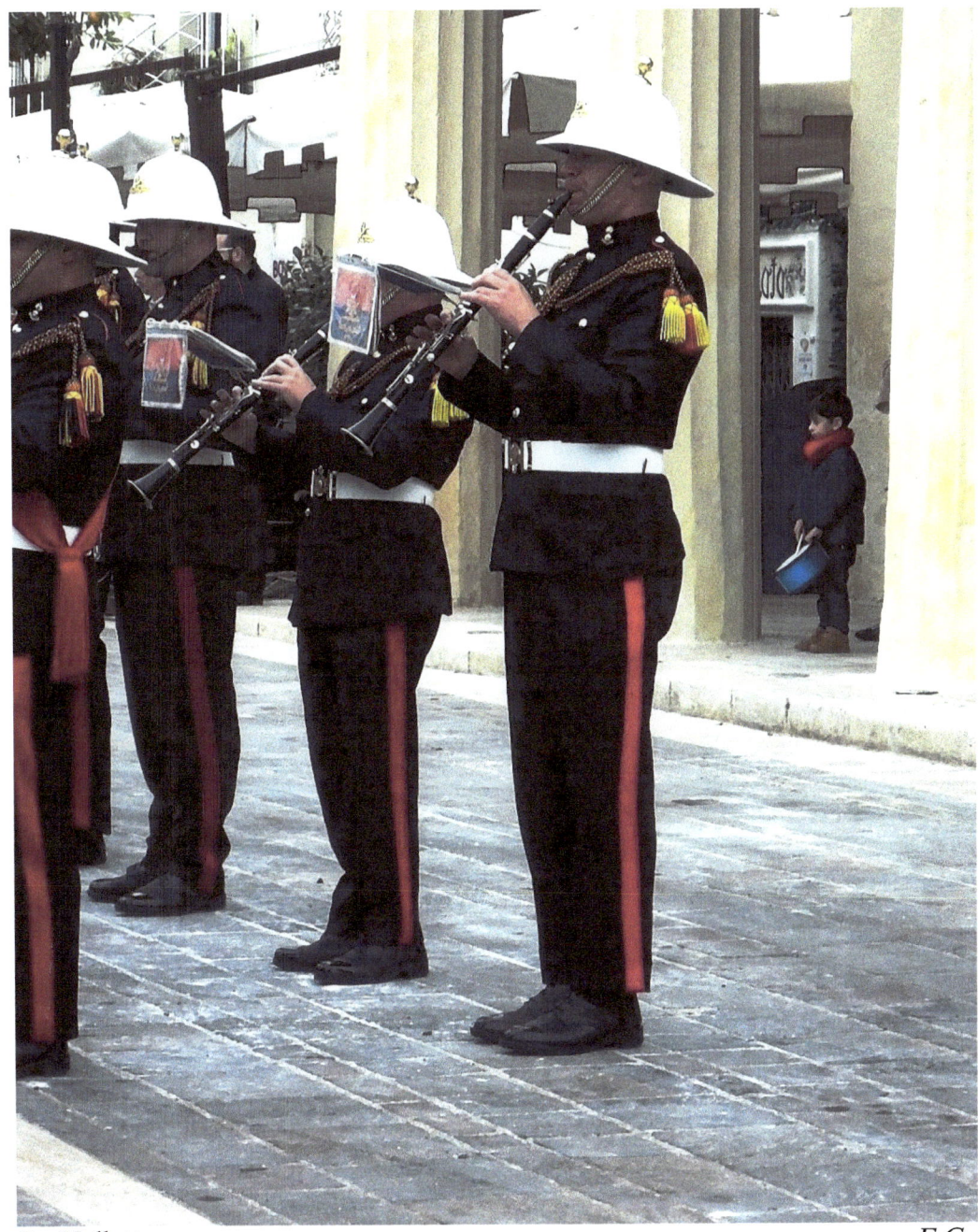

La Valletta — F.G.

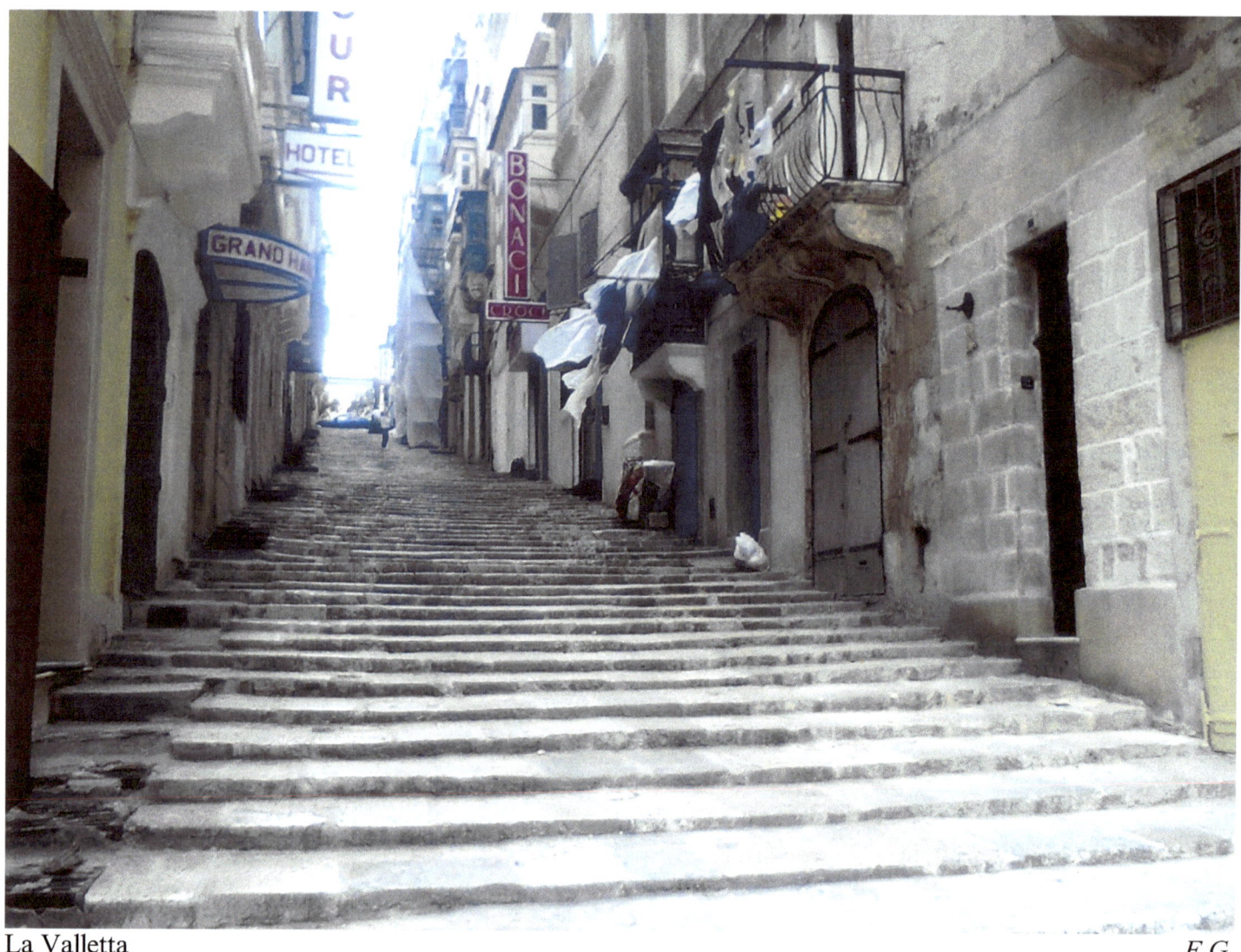
La Valletta F.G.

Kusksu, typical Maltese soup made from broad beans which time ago was prepared only during Lent, but today it is prepared all winter. It is simple and watery, with broad beans, potatoes and pasta, adding finally to the pot before serving one egg per person that you let cook like a poached egg.

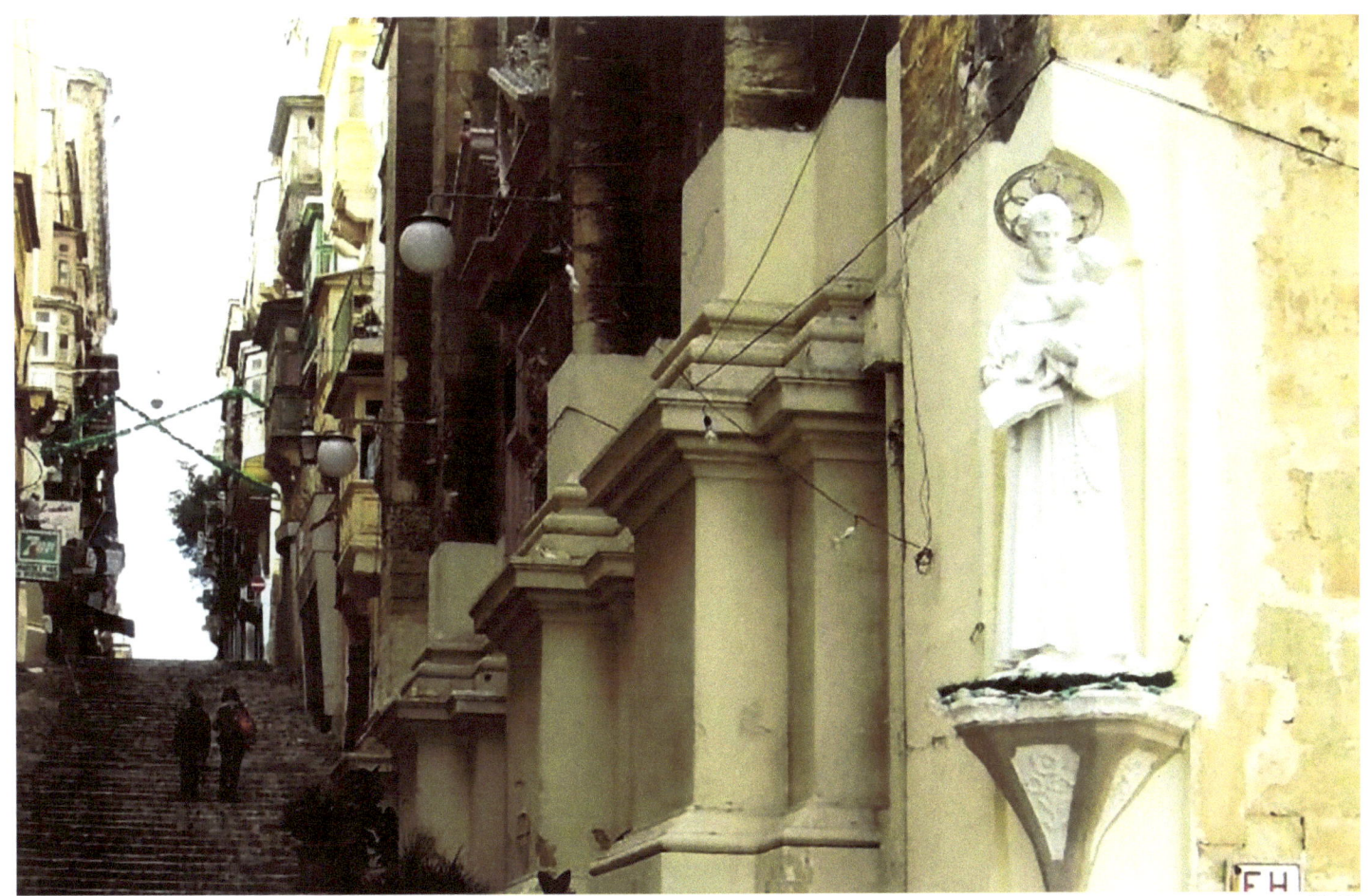
La Valletta F.G.

Hobz biz-zejt, bread slices rubbed with fresh or dried tomatoes, then soaked in olive oil, seasoned with salt and freshly ground black pepper and filled with one, or more, of the following items: canned tuna flakes, fresh onion cut into thin slices, olives, basil, fillets of salted anchovies, small Malta capers, fresh mint, sliced boiled eggs, lettuce, small pickled vegetables, beans and pickled onions.

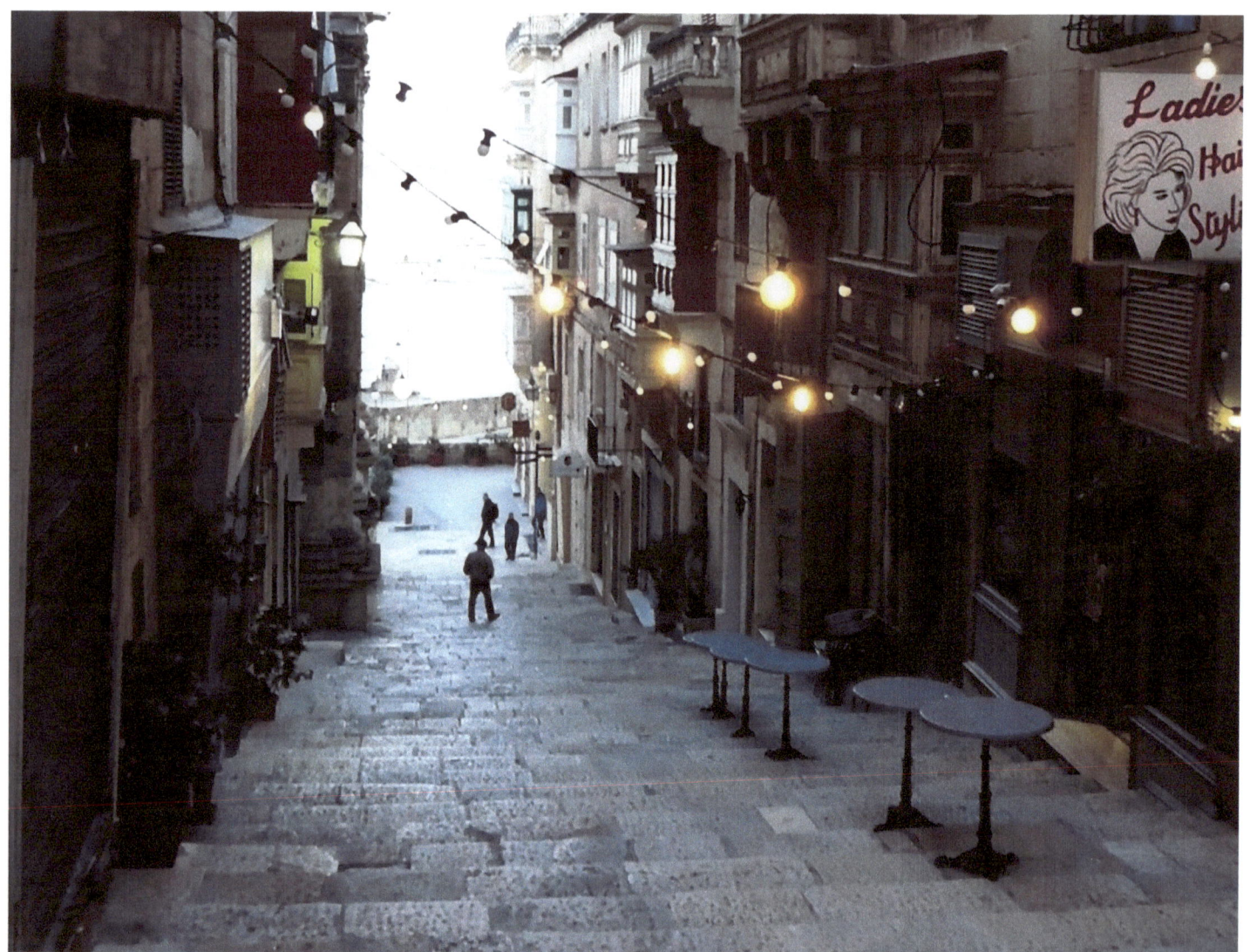
La Valletta *F.G.*

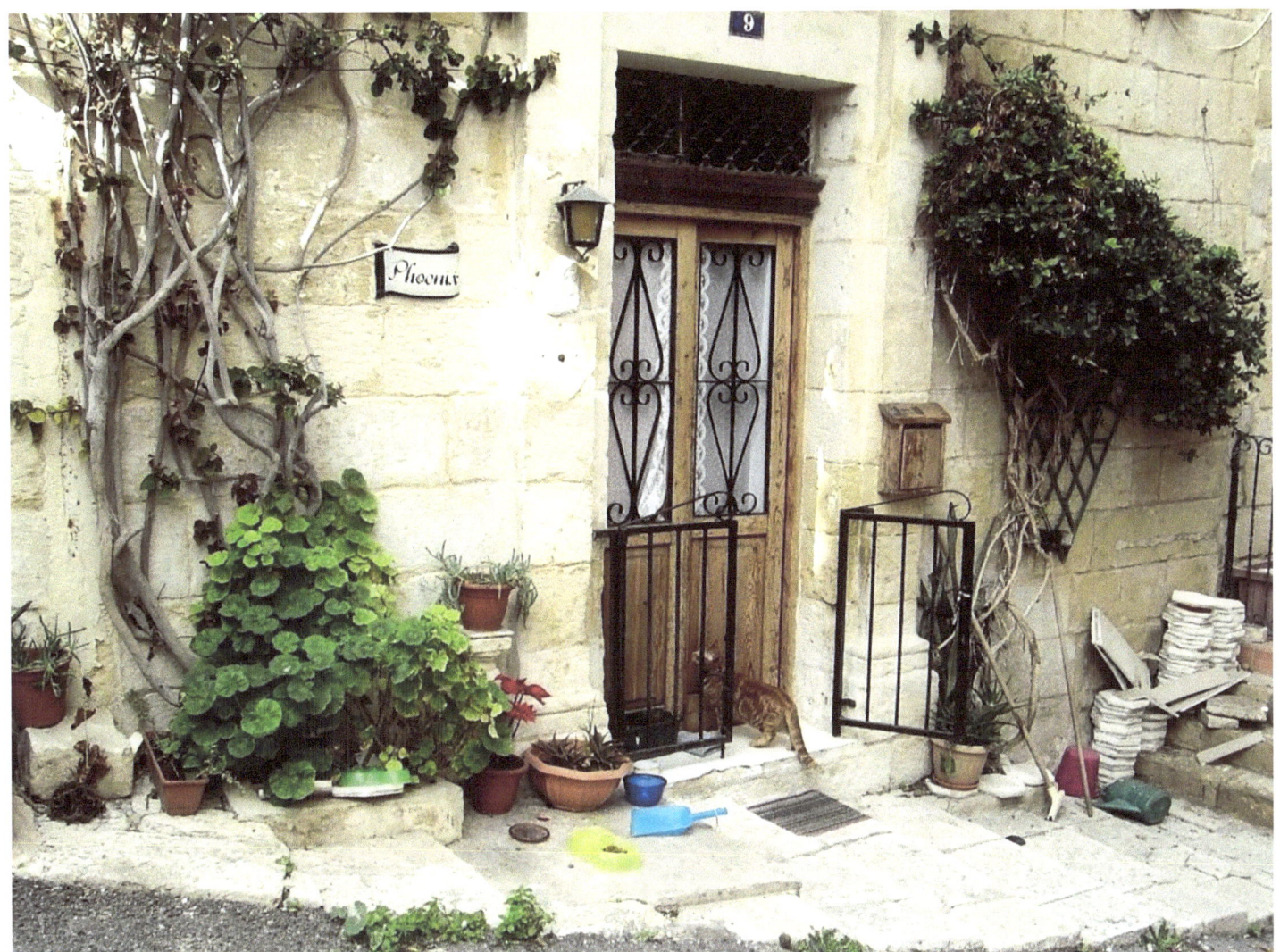
La Valletta *F.G.*

Ftira, typical Maltese pizza. It is a cake stuffed in the most tasty and creative ways, with capers, cheese, onion, tomato, olives, anchovies, basil, potatoes and tuna. Or tomato, Maltese sausage, bacon, cheese, and rosemary potatoes. Or dried tomatoes, baked broad beans, garlic and mozzarella. In Lent it is made with pumpkin, rosemary, potatoes, olives, honey and anchovies.

La Valletta F.G.

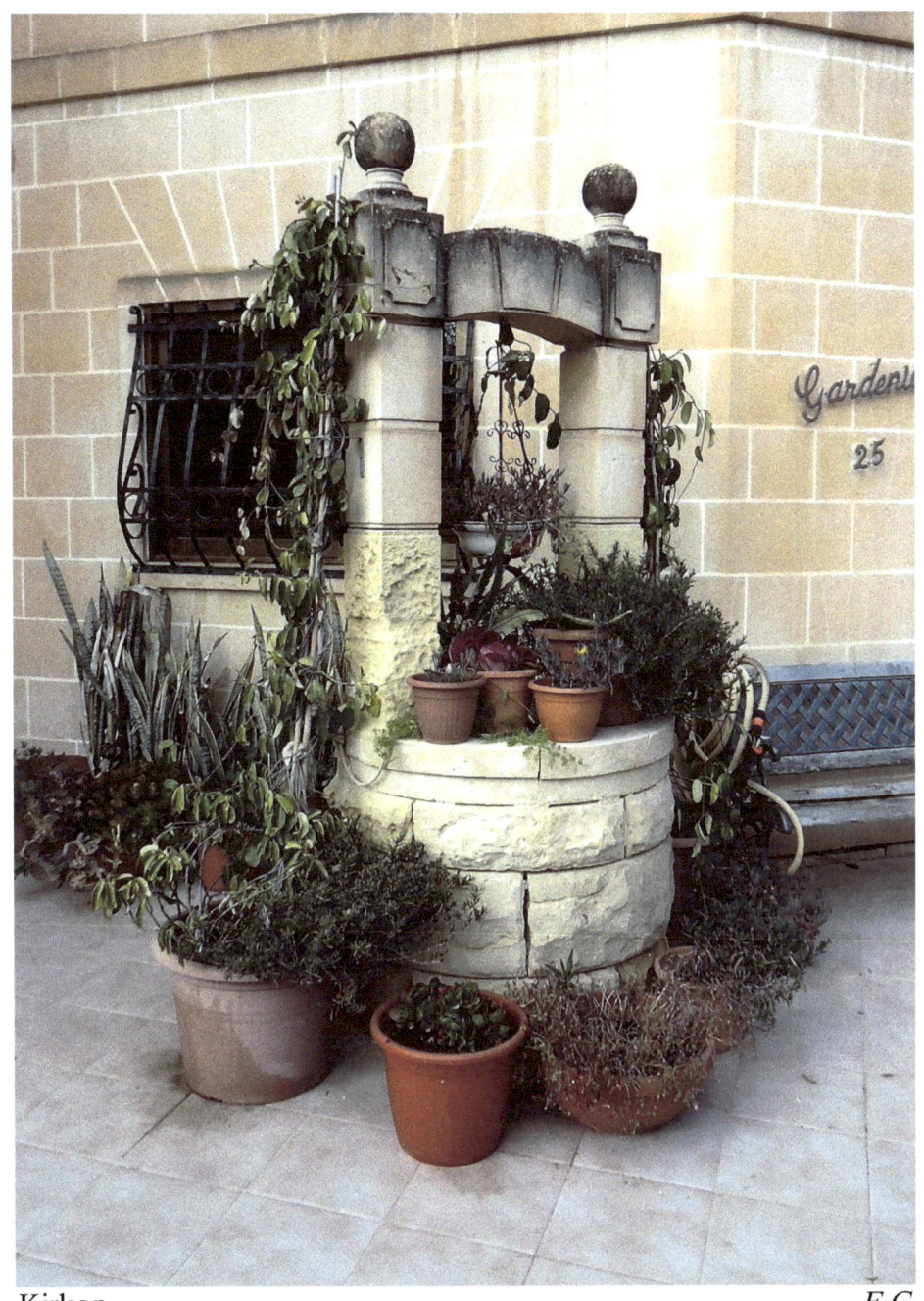

Kirkop	F.G.

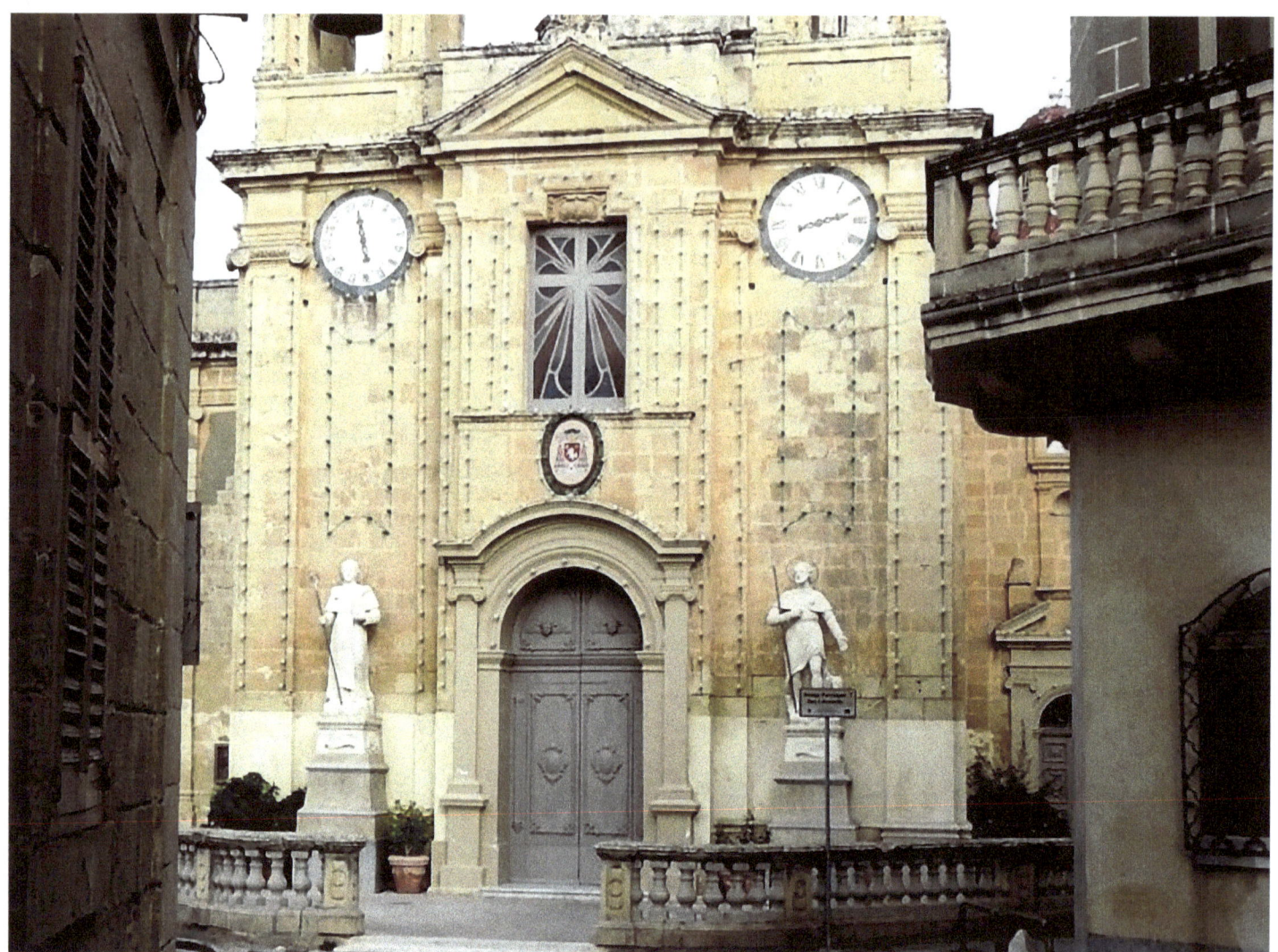

Kirkop *F.G.*

Safi *F.G.*

Stuffat tal-Fenek, the national dish of stewed rabbit. Marinate the rabbit in wine, garlic and bay leaves in the evening before cooking. Cover and cool in the fridge. Remove the rabbit from the marinade, shaking off any excess liquid. In a saucepan saute the rabbit in olive oil over high heat on all sides until golden brown. Remove it and set aside. Lower the heat and add in the same pan the onion and bay leaves. Lightly brown the onion, then add the garlic and continue for another minute. Add the tomatoes and increase the heating. After 5 minutes of cooking add the marinade and bring to boil. Return the rabbit to the pan and fill with water until to cover it. Put the lid and return to the boil, then reduce to medium heat. After half an hour add the carrots, potatoes and tomato puree. Continue to cook the stew for about another half hour. After an hour of baking put the lid in half to thicken the sauce. The stew is ready when the rabbit detaches from the bone and the vegetables are tender. Serve with fennel seeds and roasted potatoes or mashed potatoes and white bread crusts to dip in the sauce.

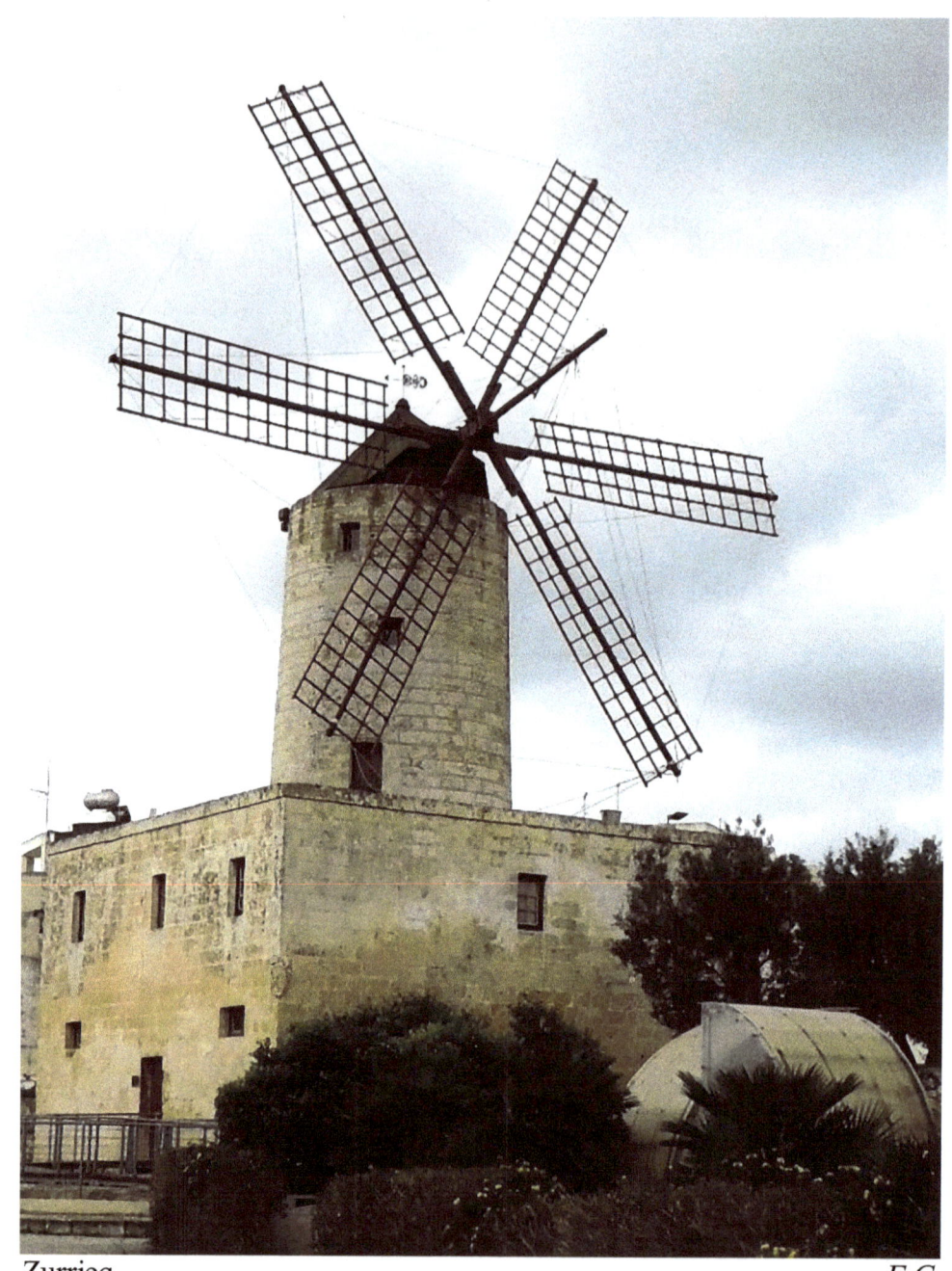

Zurrieq F.G.

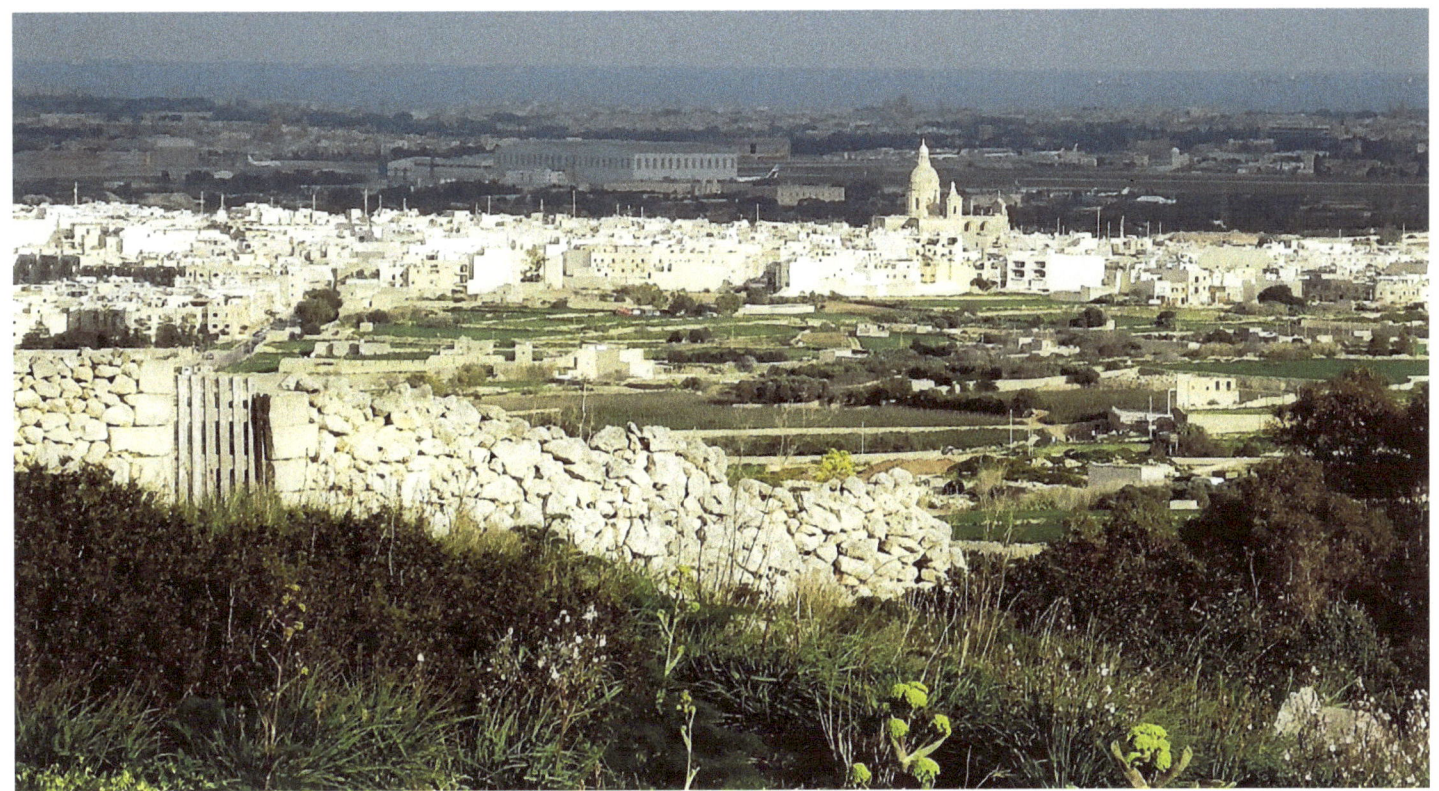
Siġġiewi *F.G.*

Aljotta, fish soup with garlic, tomatoes and rice. Clean the fish and wash it, cut the heads and boil for 15 minutes with herbs and a pinch of salt to the broth. Cut the fish into medium sized pieces. Then in a saucepan saute the garlic and onion finely chopped in a little oil for a few minutes. Add the tomatoes, mint, marjoram and continue with high heat for two minutes. Pour the broth and simmer until the sauce has thickened a bit. Add the fish pieces and continue cooking reducing the flame, for another ten minutes. Add salt and pepper. Serve the hot soup with boiled rice.

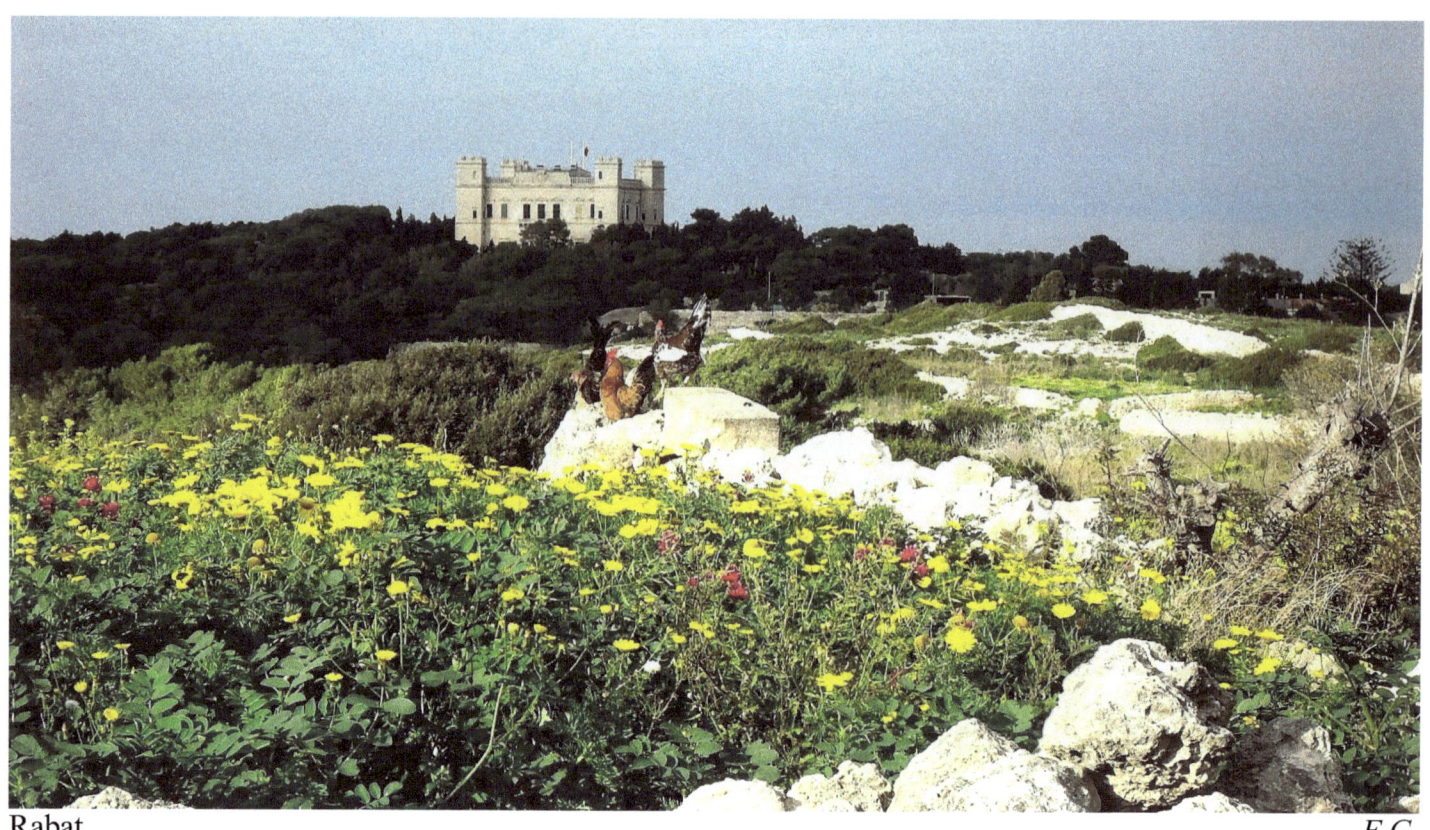
Rabat F.G.

Ravjul, ravioli stuffed with meat or ġbejna, the Gozitan goat cheese. Heat the butter and oil in a medium sized pan, add the celery, carrot, onion and saute over medium heat for 3-4 minutes. Add chicken and continue to cook for another some minutes. Add the sherry and cook for one minute, then remove the mixture from heat and shake it finely. Add the egg yolks, salt, pepper and mix well. Let cool before using.

Dingli *F.G.*

Fenkata, full meal of rabbit which includes spaghetti with rabbit sauce stew in Maltese way (*spagetti bil zalza istuffat tal-fenek*), fried rabbit in garlic with fried potatoes (*fenek moqli fit-tewme*), roast rabbit with potatoes flavored with aniseed (*fenek fil-fom*), marinated rabbit in wine and stew with tomatoes and onions (*stuffat tal-fenek*), nuts and figs for dessert.

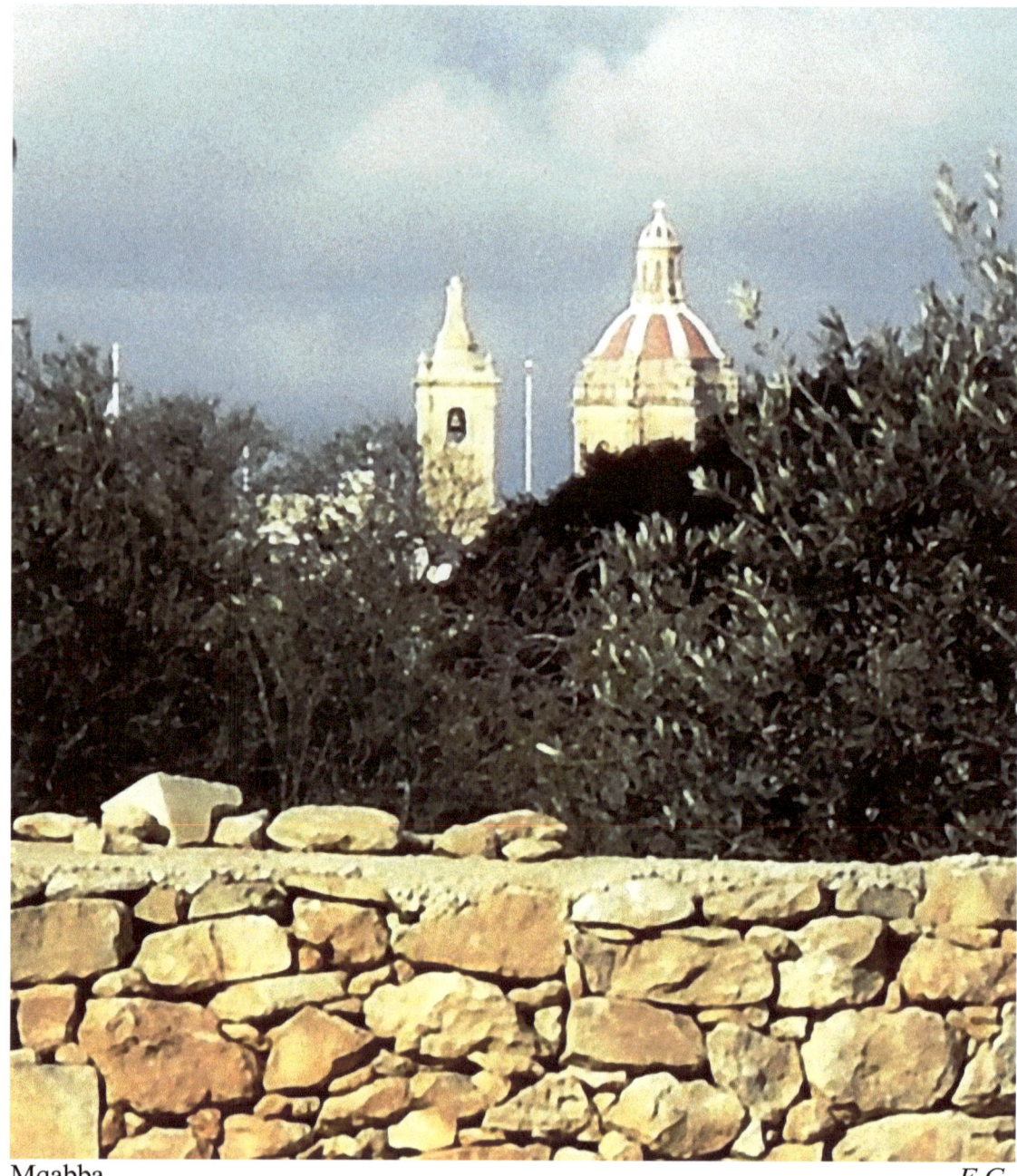

Mqabba *F.G.*

F.G.

Torta tal-Lampuki, fish soup. Brown the onion and when becomes beautiful golden pour the tomato pulp. Cook over low heat for 5 minutes then add the capers and olives. Season with salt and pepper and cook for another 5-10 minutes over a low heat until it thickens. Wash the fish with water and salt, flour and fry a couple of minutes on both sides.

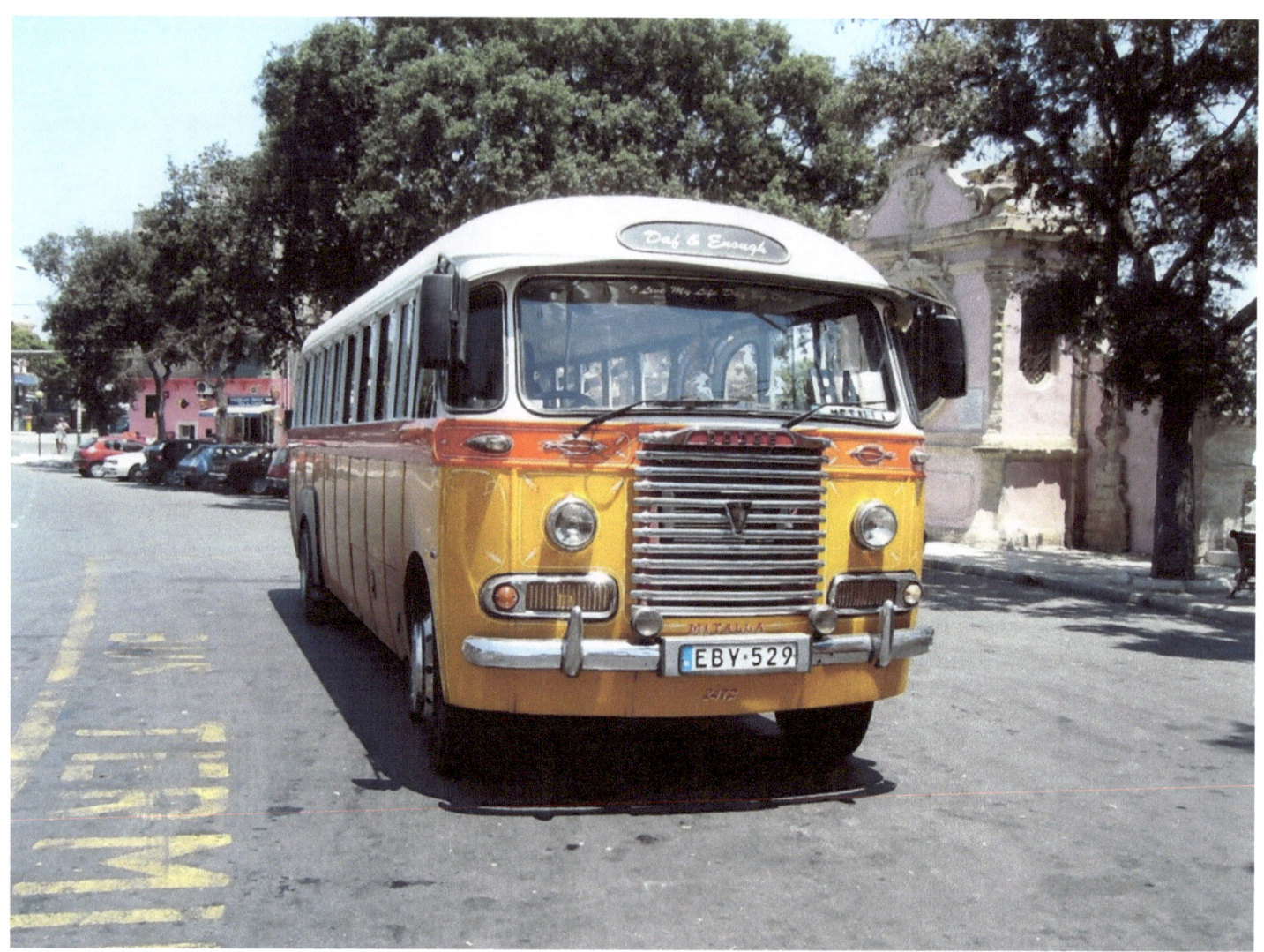

Mdina *F.G.*

Pastizzi, pastries filled with ricotta (*pastizzi tal-irkotta*) or a filling of peas (*pastizzi tal-pizelli*). Mix together in a bowl the ricotta, parsley, eggs, salt and pepper. Roll out the puff pastry to obtain a thin layer. Derive some circles of 9 cm in diameter. Brush the edges of the circles with beaten egg and place a spoonful of filling in the center. Close and fold the edges joining them together. Brush the outside with the remaining egg and bake in oven for about 30 minutes at 200 degrees.

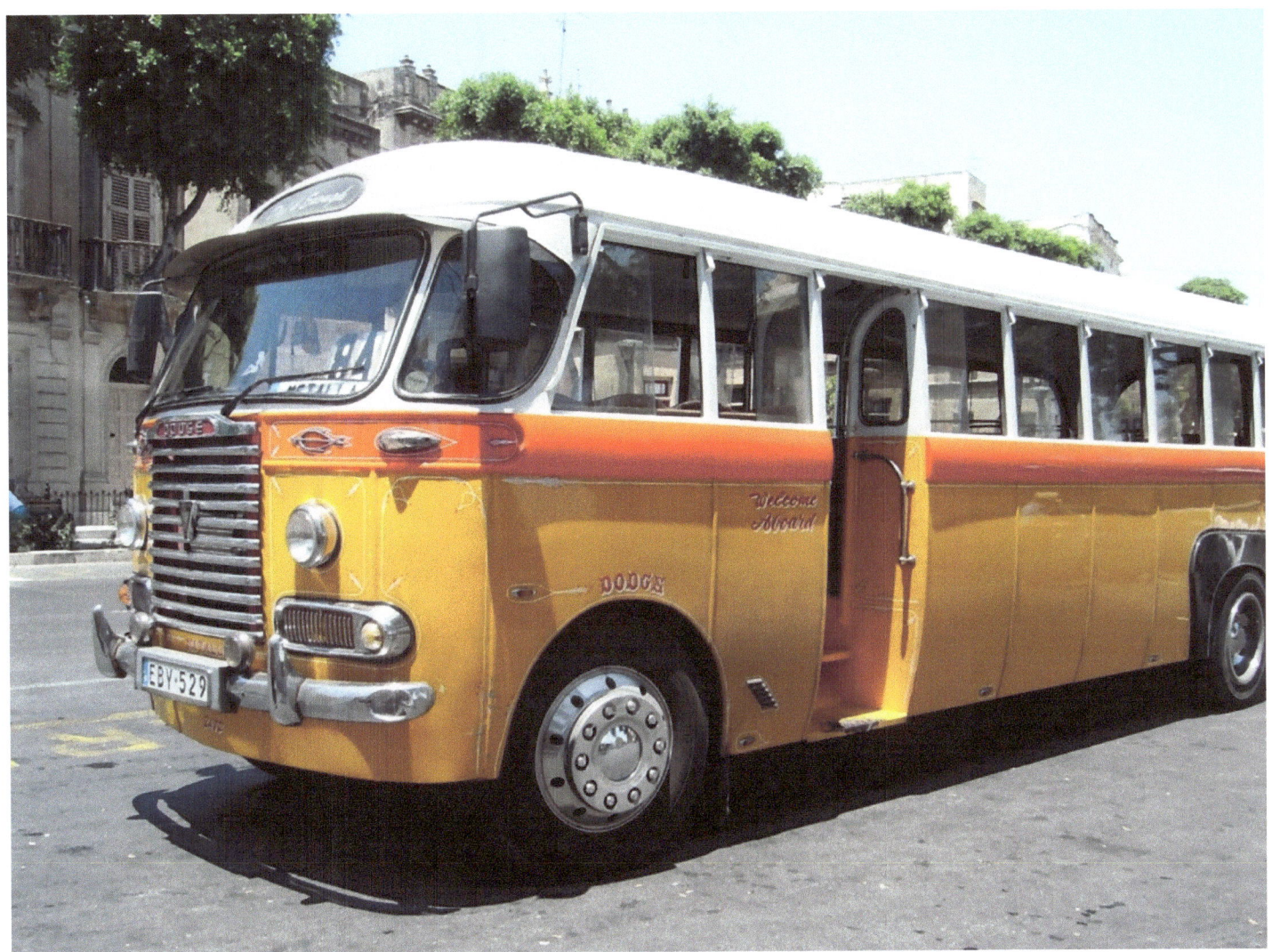

Mdina　　　　　　　　　　　　　　　　　　　　　　　　　　　　　　　　*F.G.*

Laħam taz-ziemel, horse meat cooked steamed or fried with garlic or stew or in the oven with onion sauce and red wine. Marinate the horse meat in the red wine and salt. Grate finely the lemon zest and orange. Cut the onion, garlic, basil, marjoram and paprika. Add conserve and finally the meat. Cook on low heat for two hours.

F.G.

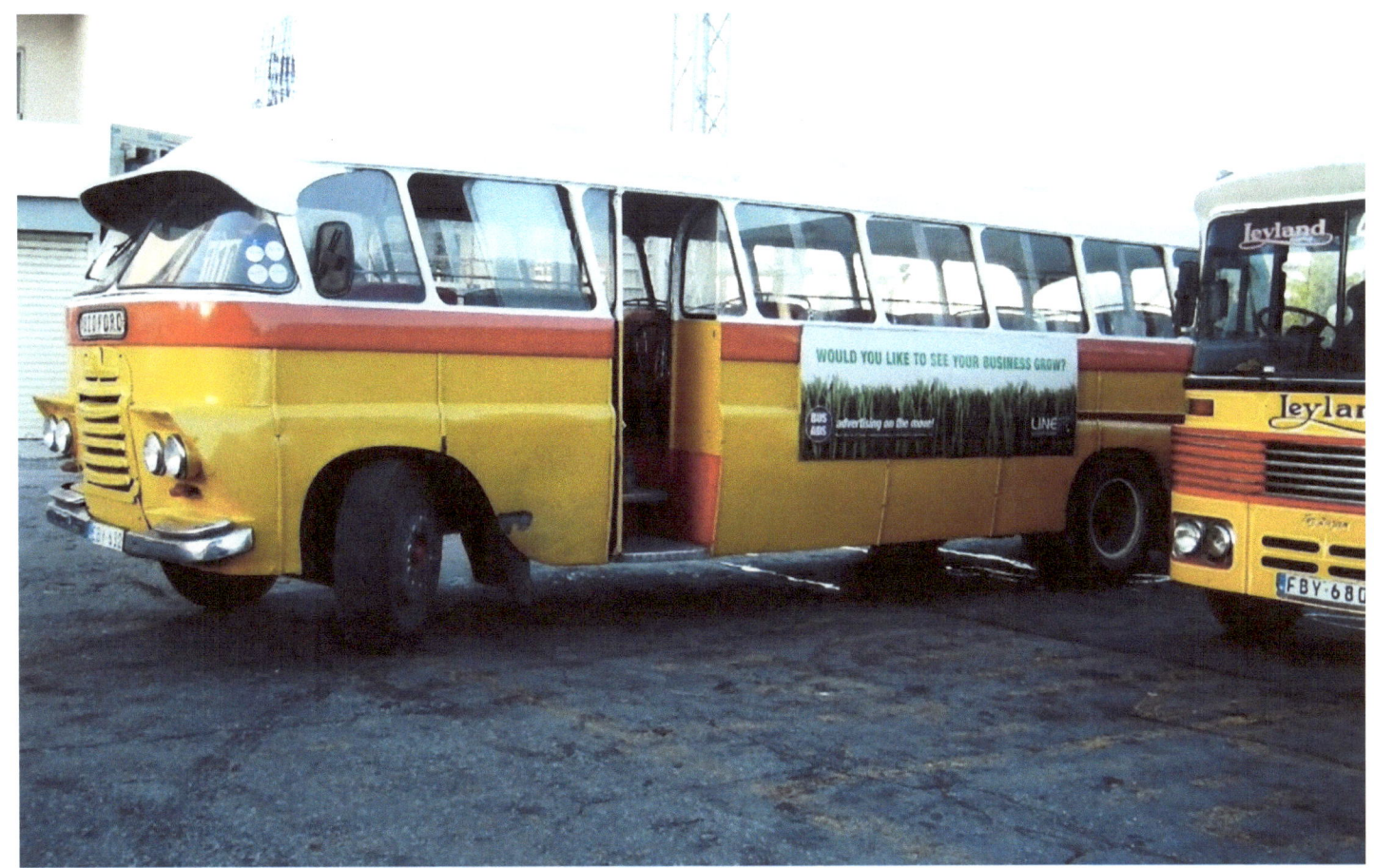

Birzebbugia　　　*F.G.*

Bebbux, on the occasion of Good Friday in Malta the snails are served with full garlic sauce. Wash the snails one by one with salt water, repeating the procedure at least three times! Boil water in a nice large pot, add salt and the snails. The snail is ready when it comes away easily from the shell. Arrange on the basis of a rectangular pan the sliced onions and garlic. Lay over the potatoes, diced tomatoes, mint, basil, salt and pepper. Now put down the snails with all the shells, another tomato into cubes and again mint and basil. Pour a glass of wine and lengthen with other water until to cover potatoes at three quarters. Cover with aluminum foil and bake for about 30 minutes at 200 degree.

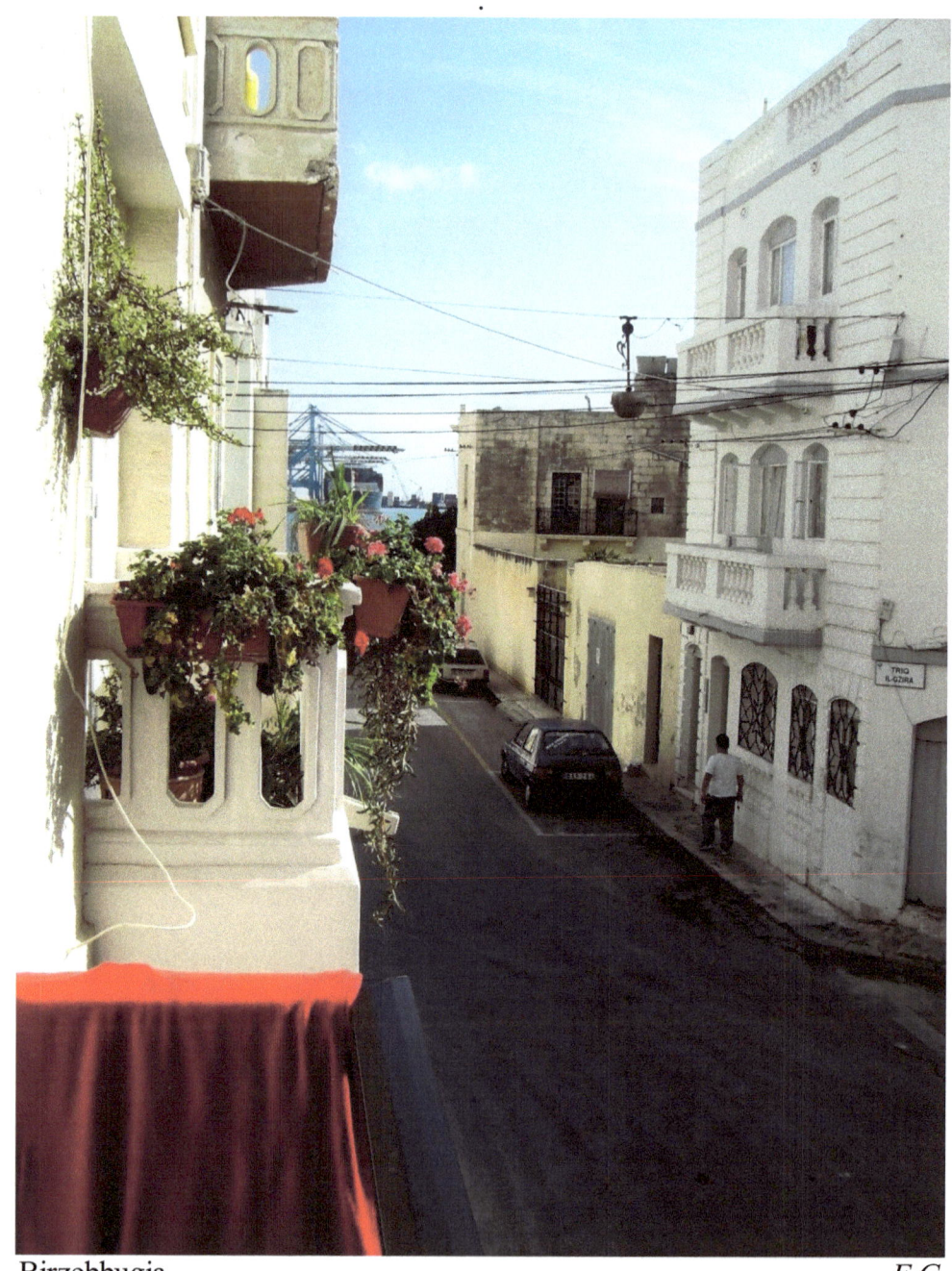

Birzebbugia F.G.

Birzebbugia E.K.

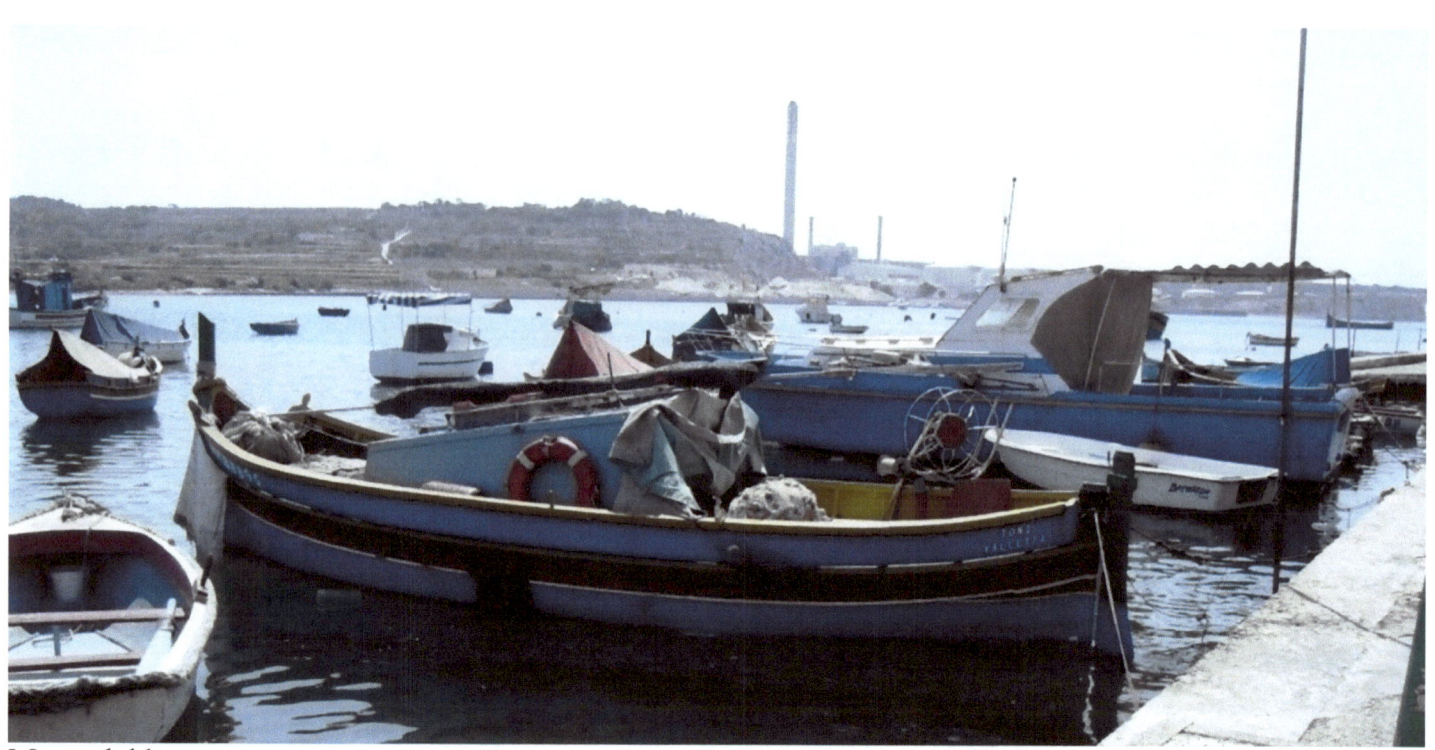
Marsaxlokk F.G.

Ross Fil-Forn, the risotto with lard, onion, minced meat and tomatoes. Heat the oil in a skillet over medium heat and add the minced meat. Cook stirring until the meat is browned. Add the chopped tomatoes, chicken stock and bay leaves. Simmer for 25 minutes over low heat. Meanwhile, put the rice in a saucepan, add enough water to cover the rice and bring to a boil. Cook for about 10 minutes, until half cooked, then drain the rice. Remove the bay leaves from the compound and add the rice. Add the basil and chopped mint, eggs, mozzarella cut into cubes, salt and pepper. Pour everything to a baking dish greased oven, then sprinkle with Parmesan cheese. Bake for about 30 minutes, until the rice is tender and the liquid has been absorbed.

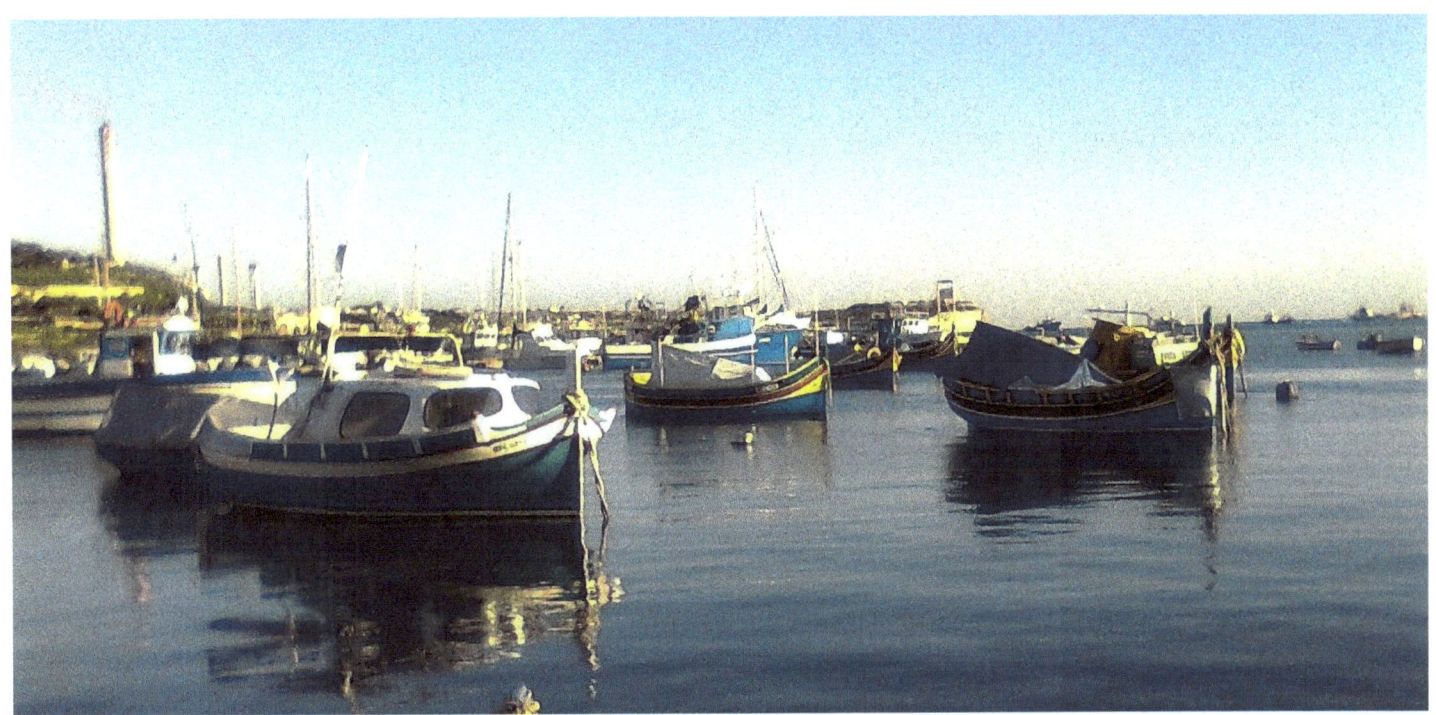
Marsaxlokk E.K.

Qaghaq tal-ghasel, traditional stuffed Christmas donuts with sugar, cocoa, semolina and covered with molasses. Pour the semolina and butter into cubes in the mixer and knead at low speed. Add the water and the orange juice and knead for 5 minutes until the dough does not is too soft. Wrap in plastic wrap and let rest. In a large saucepan put all the ingredients (molasses, sugar, cocoa powder, semolina, cloves, orange zest and lemon, anise, water) and bring slowly to a boil, stirring constantly. When the mixture boils, remove from heat and add the flour slowly, stirring all the time in order to remove any lumps. Put on the heat and bring back to a boil. Cook for another 5 minutes, stirring constantly, otherwise the semolina sticks to the bottom. Remove from heat and let cool. Flour the work surface with the semolina, roll out the dough and cut into strips, spread the filling in the center of each strip, leaving a centimeter at the edges. Seal edges, roll up so as to seal well, moisten ends with the water, give a circular form and close together. With a sharp knife, make diagonal cuts on the top. Arrange on a dusted baking sheet with semolina and bake until the dough has a slightly golden color.

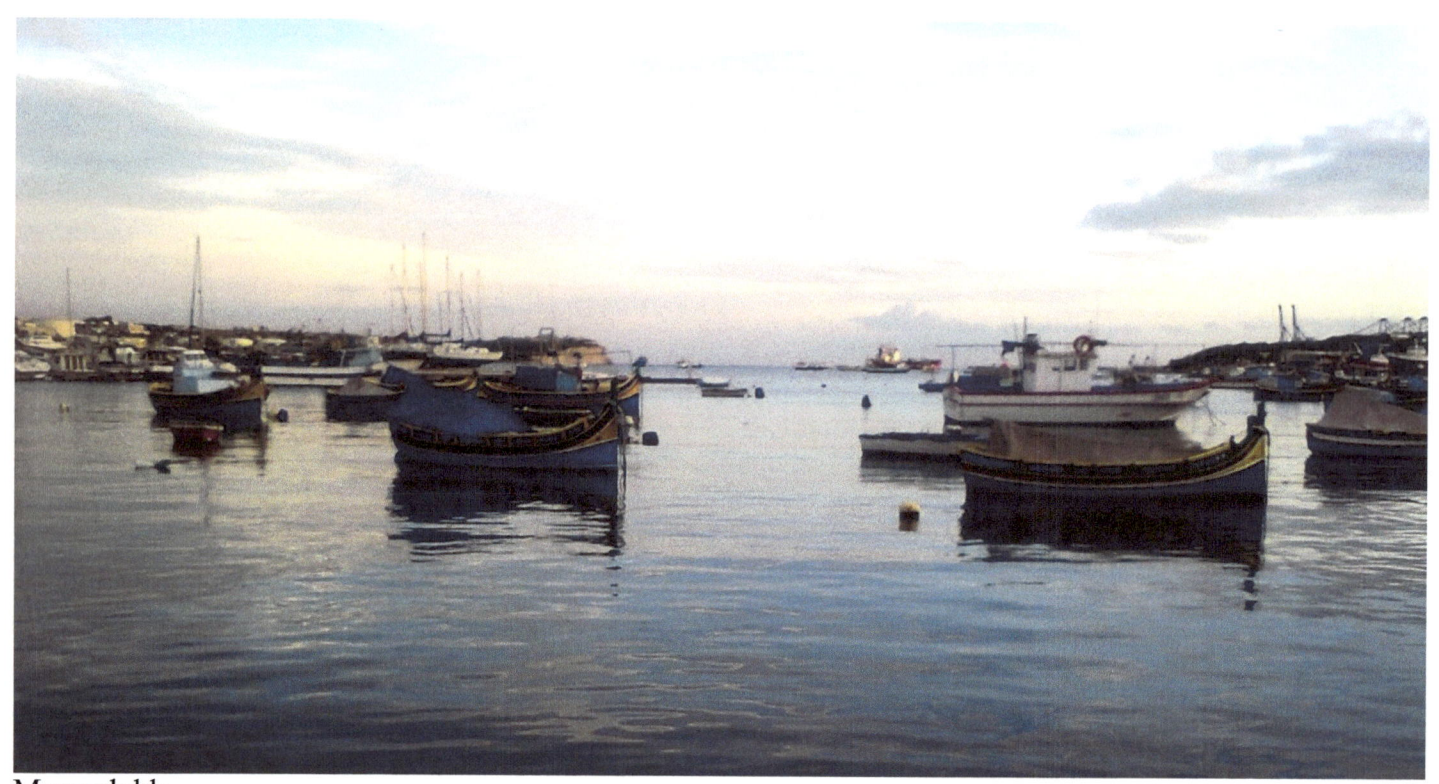
Marsaxlokk F.G.

Imqaret, fried pastries stuffed with dates. Combine all ingredients for the dough (flour, butter, margarine, sugar, anisette, orange essence and water) and mix with each other by mixing for good. When the mixture becomes homogeneous put it aside for half an hour. In a saucepan with a little water put the dates and let them warm up for a few minutes, then add, stirring, the grated lemon peel, orange and tangerine, the orange juice and anisette. Roll out the dough into long strips about 10 cm and brush the edges with water. Put the filling in the center of each strip and fold the edges, pressing so as to avoid the filling comes out. Cut each strip into rhombs of about 4 cm in length each. Fry in abundant oil, until golden brown. Drain, so as to expel excess oil, and serve.

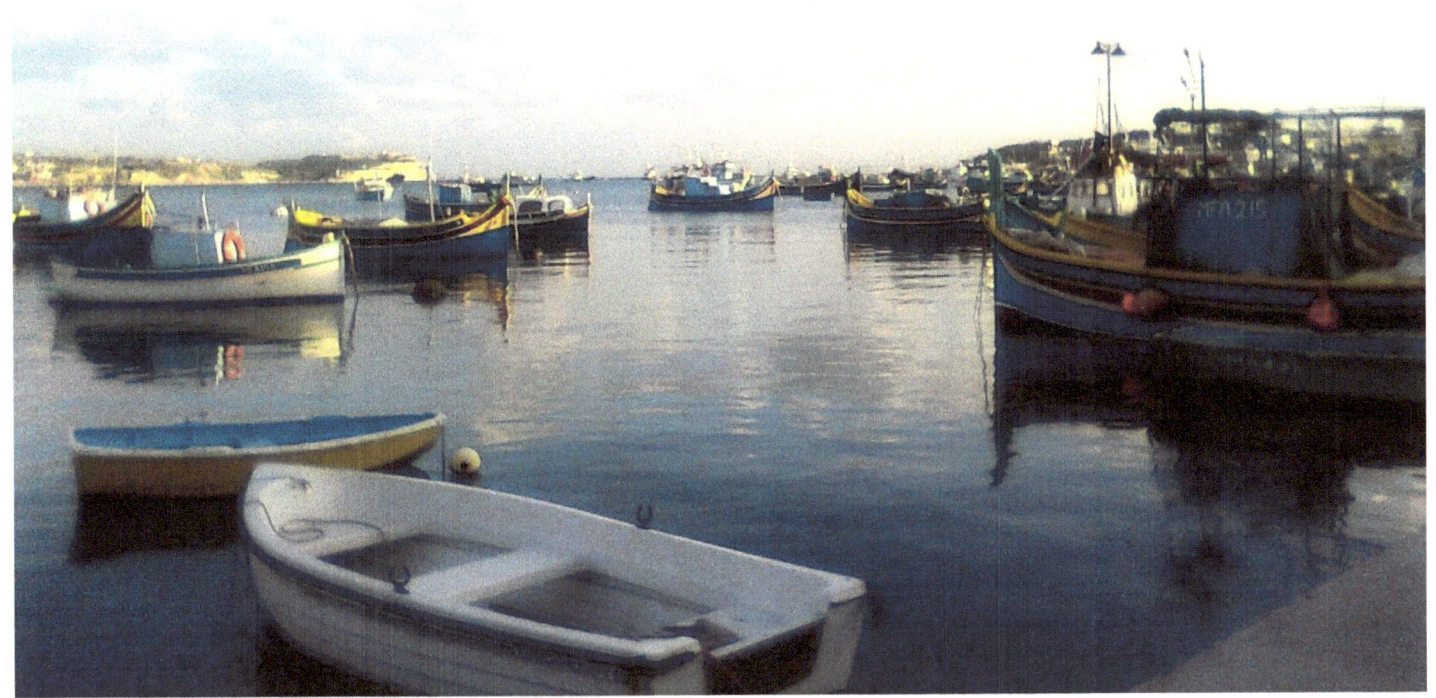
Marsaxlokk *E.K.*

Helwa tat-Tork, sweet made with chopped and entire almonds, served after dinner with coffee. Dissolve the sugar and water over low heat. Boil the caramel up to 140 degrees. Meanwhile in another saucepan mix well the tahini (sesame paste), vanilla and almonds. When the caramel will be on temperature pour it in the compound of tahini and almonds. Mix everything very well and very quickly, because in a very short time the mixture, hardening, will become a thick block, difficult to work. Transfer it in a tightly sealed container to cool. More it rests, more this sweet best expresses the flavors and aromas.

Marsaxlokk F.G.

Bigilla, appetizer of broad beans with garlic and parsley. Soak beans and replace water the next day. Bring to boil in salted water and keep simmering until beans are soft. Drain the beans and mash them lightly. Allow them to cool off a little and place them in a serving dish. Pour olive oil on top and mix well untill you get a creamy sauce. You can add other ingredients to taste.

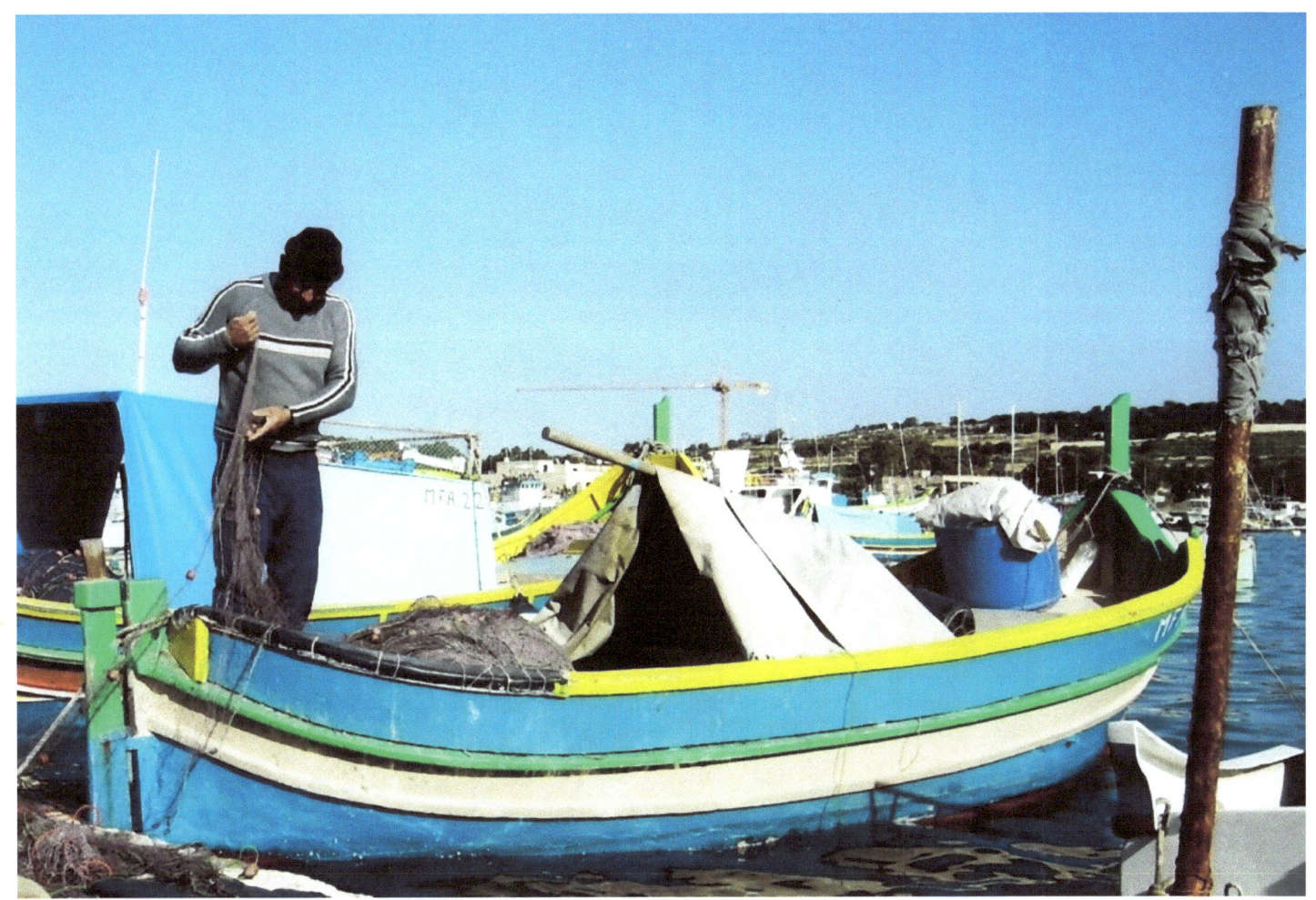
Marsaxlokk　　　　　　　　　　　　　　　　　　　　　　　　　　　　　　　　　　　　F.G.

Qaqocc mimli, Maltese stuffed artichokes. Dip the artichokes in salted water for half an hour. Meanwhile, prepare the filling by chopping the parsley, garlic and olives with bread crumbs, salt, freshly ground black pepper and olive oil. Knock the artichokes against the edge of table to open the leaves, that you will cover with the filling. Then place the artichokes upright, side by side, in a casserole. Pour water up to half the height of artichokes, add a tablespoon of vinegar, a pinch of salt and olive oil. Cover well, bring to a boil and continue over low heat. When the leaves can be easily removed, the artichokes are ready. Remove them from the water and let cool.

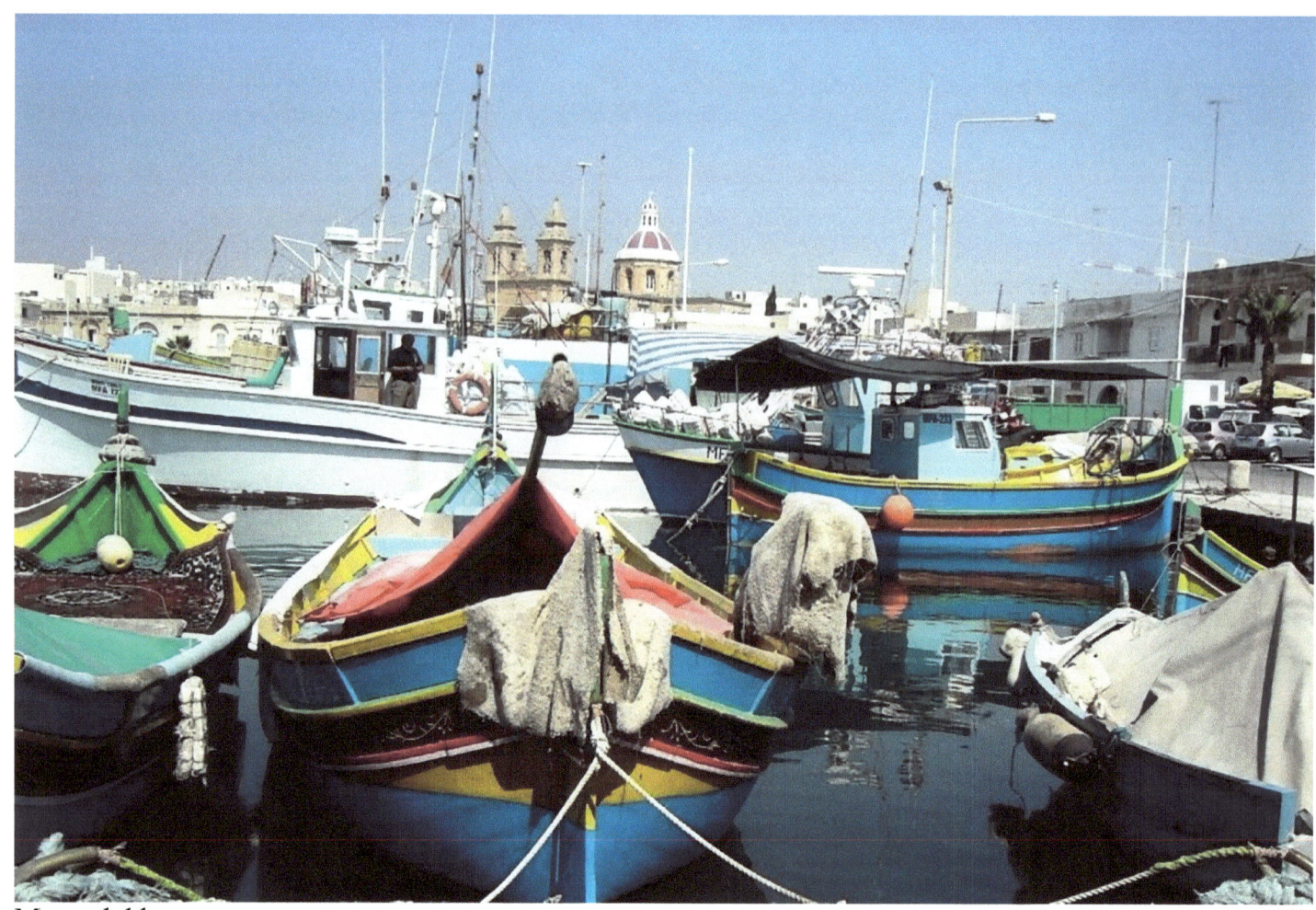
Marsaxlokk *F.G.*

Ful-bit tewm, broad beans with garlic, traditional Maltese dish eaten during Lent. The ingredients are only three: broad beans, garlic and eggs! Pour a little oil in a pan, add the peeled broad beans and chopped garlic, salt and pepper. Saute for a few minutes and when the garlic turns golden, add a little of water, cover and let cook for about ten minutes over low heat or until the water will be absorbed. Now take the egg, open it directly in the pan and incorporate it to the broad beans with a wooden spoon. As soon as the egg is cooked serve immediately.

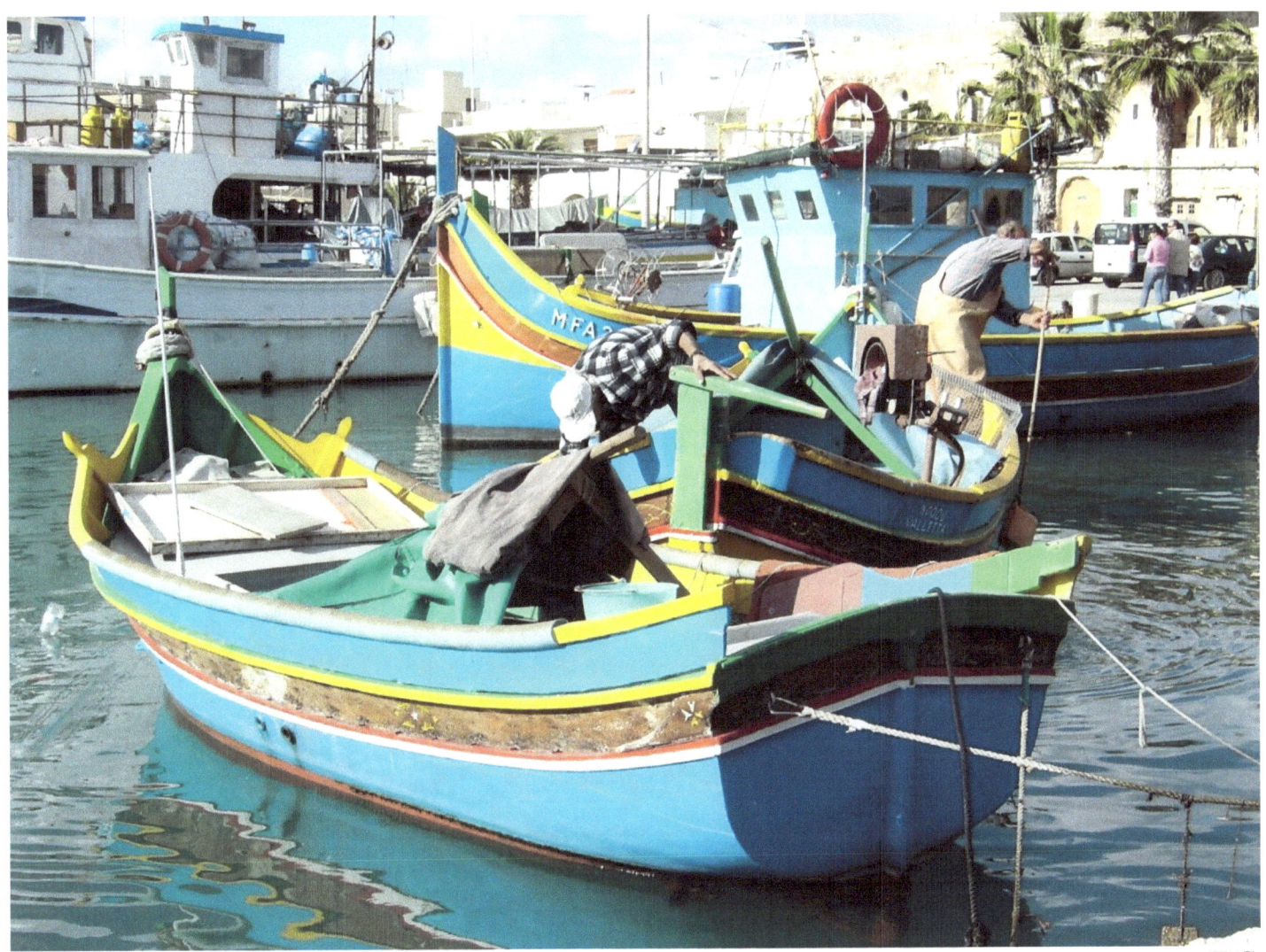

Marsaxlokk *F.G.*

Kapunata, summer dish of tomatoes, with capers, eggplant and green peppers, often served as a side dish for grilled fish or fried or cold alone as a savory lunch. Also used on pizza or pasta or Maltese bread as a snack, or mixed with cold long grain rice and served with tuna or boiled eggs for salad rice.

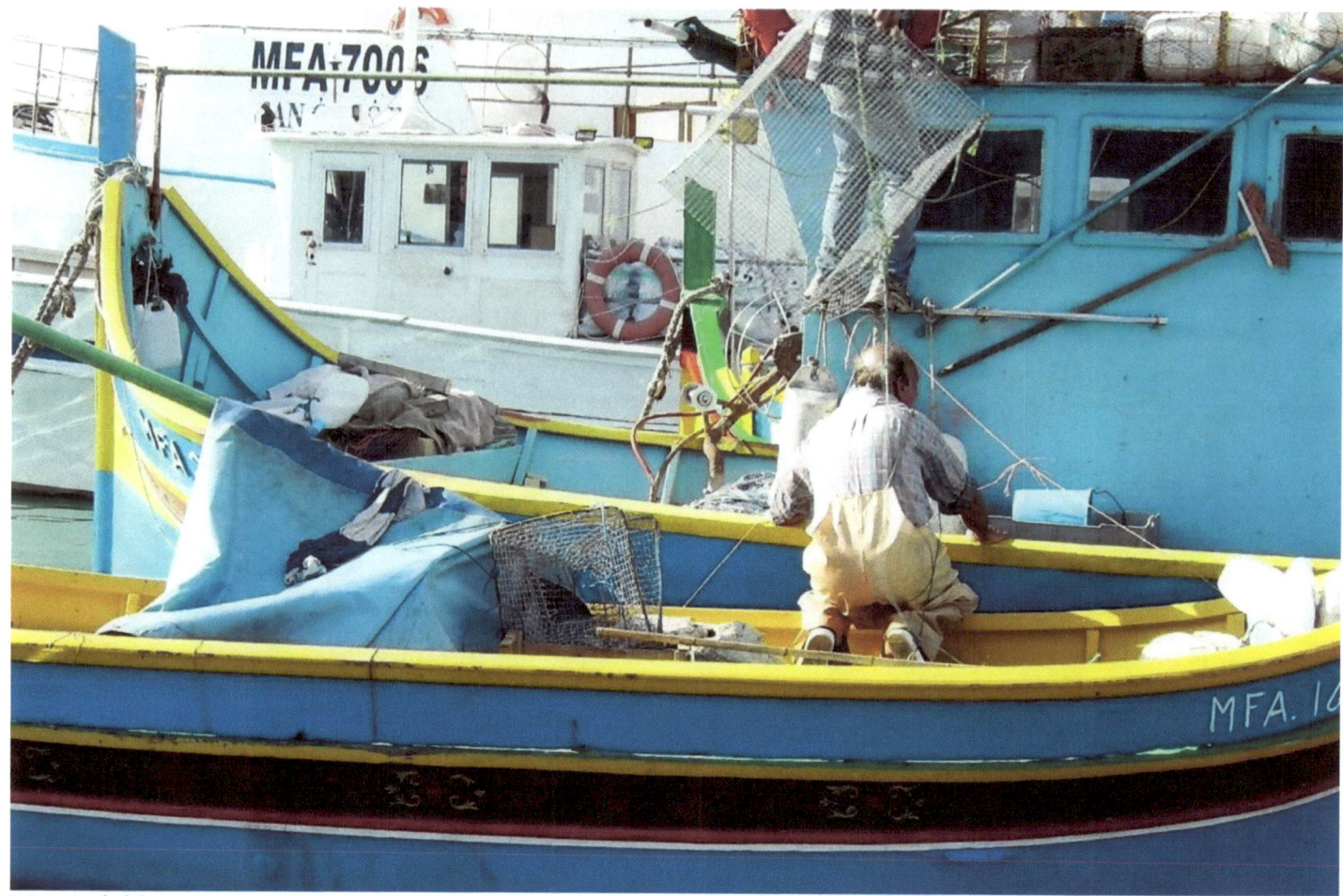

Marsaxlokk F.G.

Fritturi tal-pastard, cauliflower fritters. Boil the coarsely chopped cauliflower in salt water until it becomes soft. Then drain and let cool. Mash with a fork to reduce it to a creamy mixture, add the almond flour, egg, grated cheese, parsley, salt and pepper. A medium-low heat, add a tablespoon of oil, formed the pancakes with your hands and cook until golden brown, then flip them and cook the other side for a few minutes.

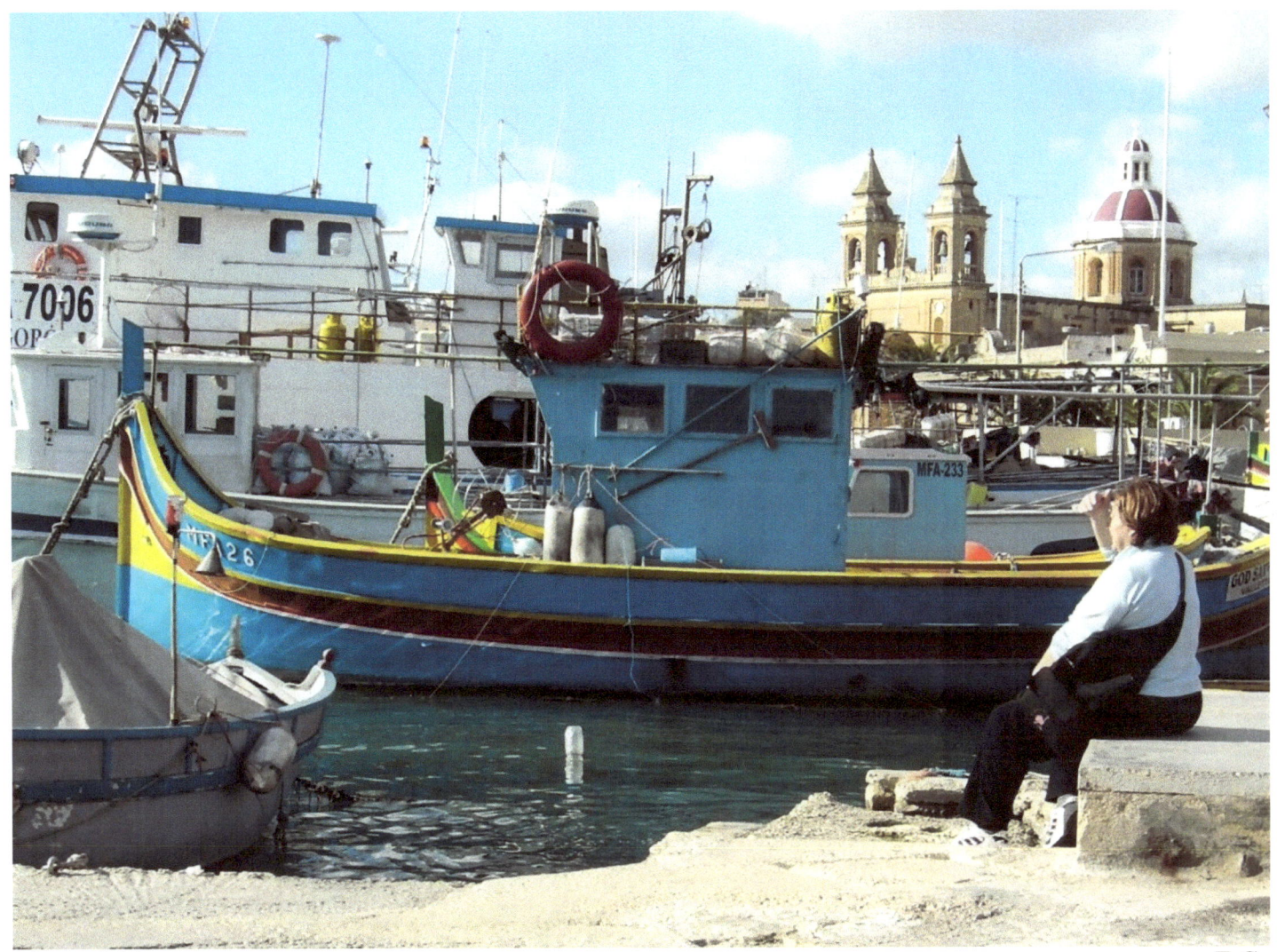
Marsaxlokk F.G.

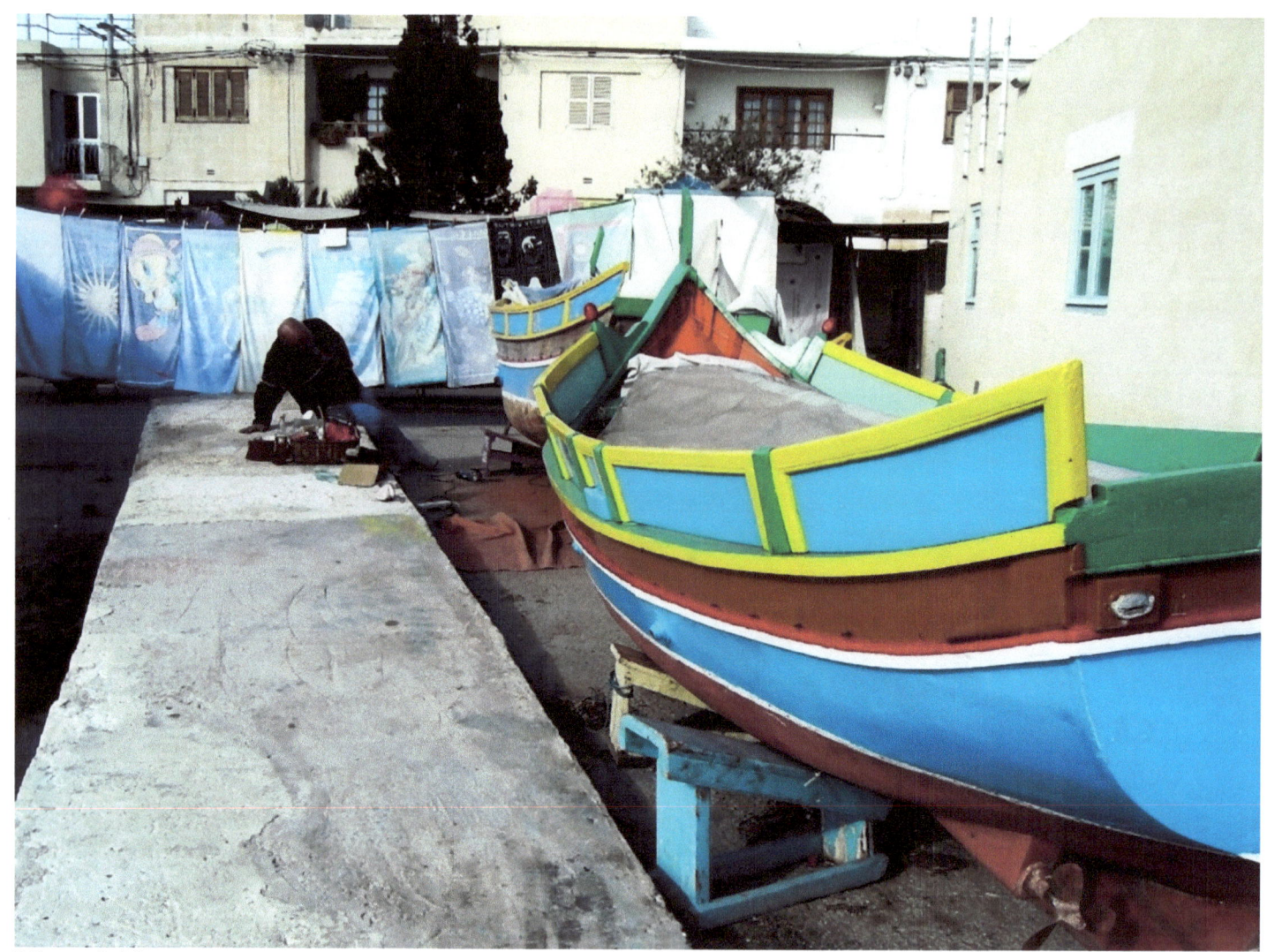

Marsaxlokk F.G.

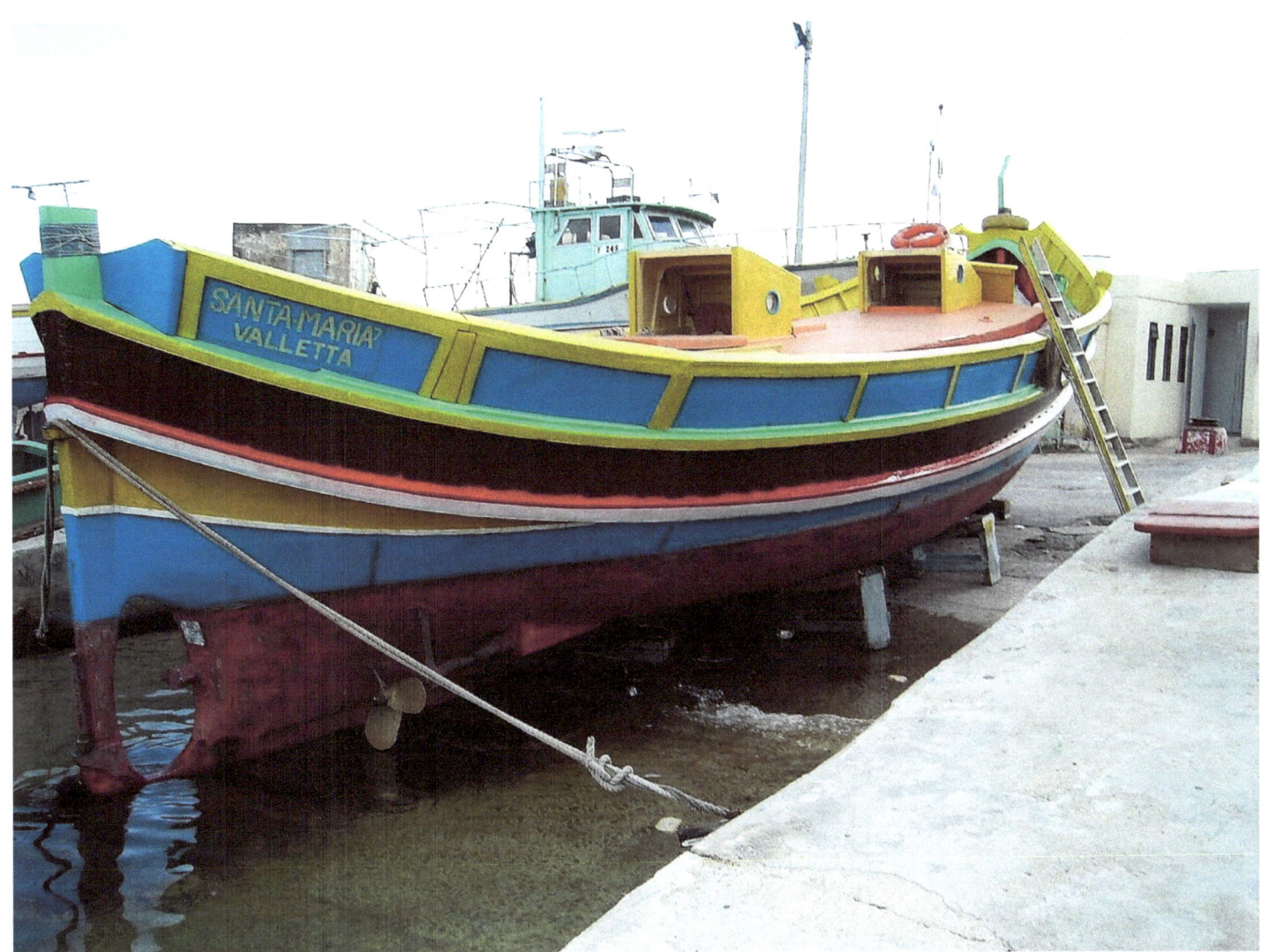

Marsaxlokk F.G.

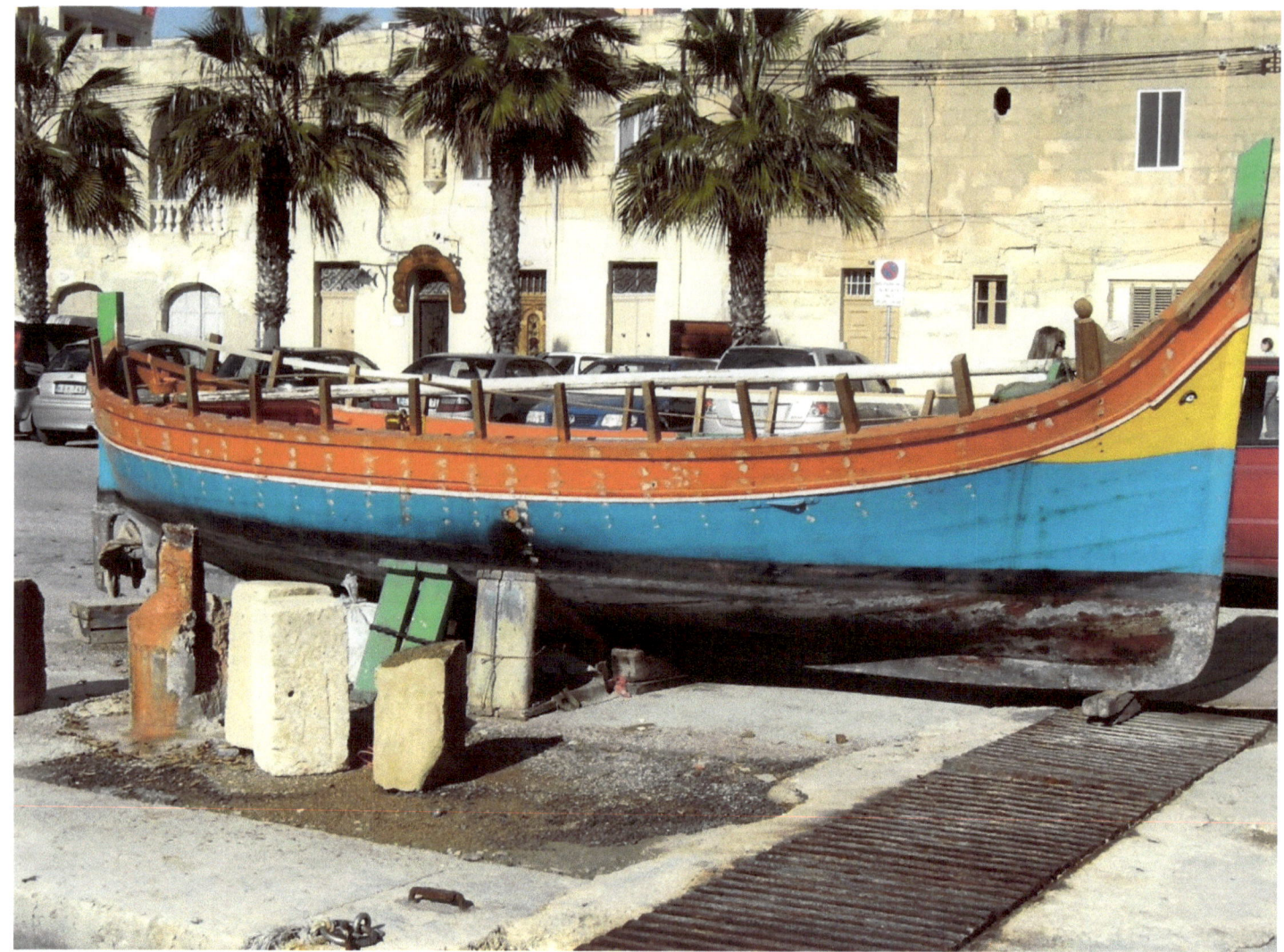

Marsaxlokk *F.G.*

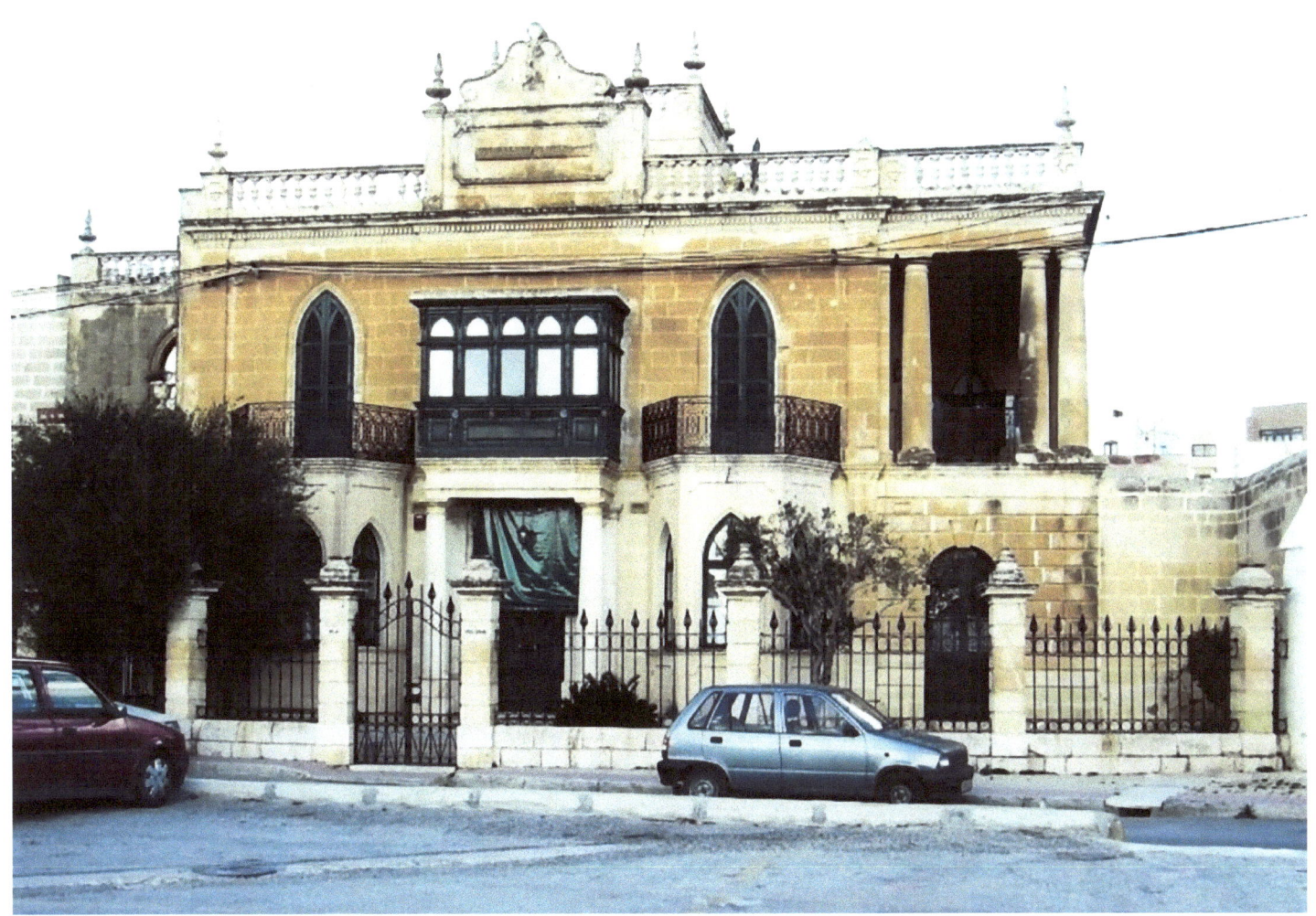
Marsaxlokk *F.G.*

Lampuki pie, salty mess of lampuki (fish of Malta) and vegetables. The fish must be cleaned and steamed or passed in the pan. Saute garlic and onion in oil, then add the peas, steamed cauliflower, olives, spinach, tomato and tomato paste, lemon zest, salt and pepper. Only at the end of cooking, add the mint and crumbled hard-boiled eggs and chopped lampuki. Roll out the puff pastry into a greased baking dish and fill with the stuffing, cover with the puff and brush it with beaten egg. Sprinkle the pie with sesame seeds and bake for 45 minutes a160 degrees.

Marsaxlokk *F.G.*

Kirxa, traditional Maltese tripe, cooked slowly with delicious vegetables and herbs. Fry the diced eggplants in seed oil. In another pan, saute the finely chopped onion and when browned, add the tomato sauce. Cook for a few minutes, then add the boiled tripe, cut into small pieces, and the diced eggplant sauce. Add salt and pepper, sugar, a bit of cinnamon and then the almonds. Continue cooking for 5 minutes and then put the pan in the oven for another 10 minute.

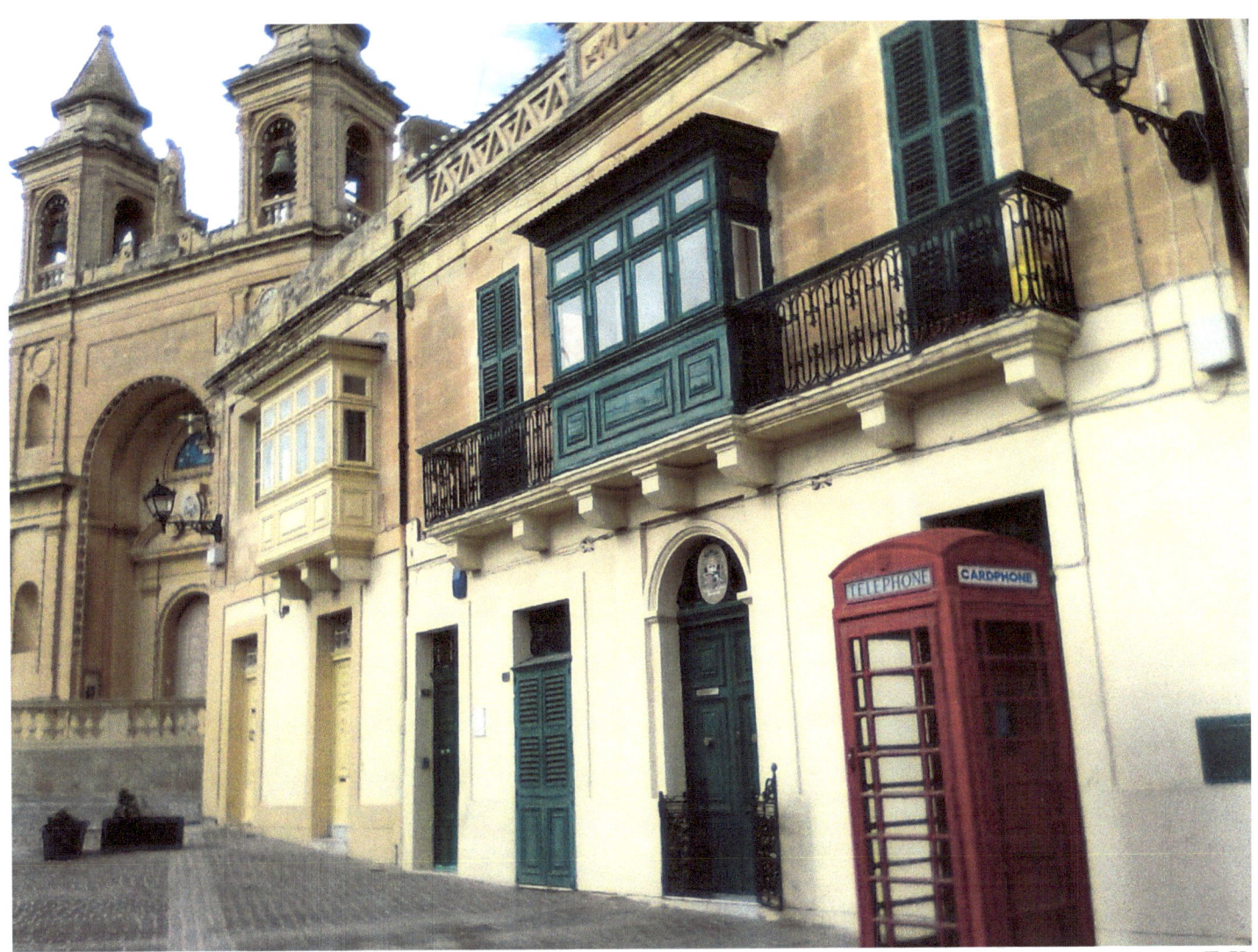
Marsaxlokk *E.K.*

Soppa tal-Fazola, bean soup. Cut the bacon into cubes and saute on minimal heat, then add the beans. Pour a bit of water and boil until the beans become soft. Add still a little of water, a tablespoon of flour, some butter, salt, pepper and paprika.

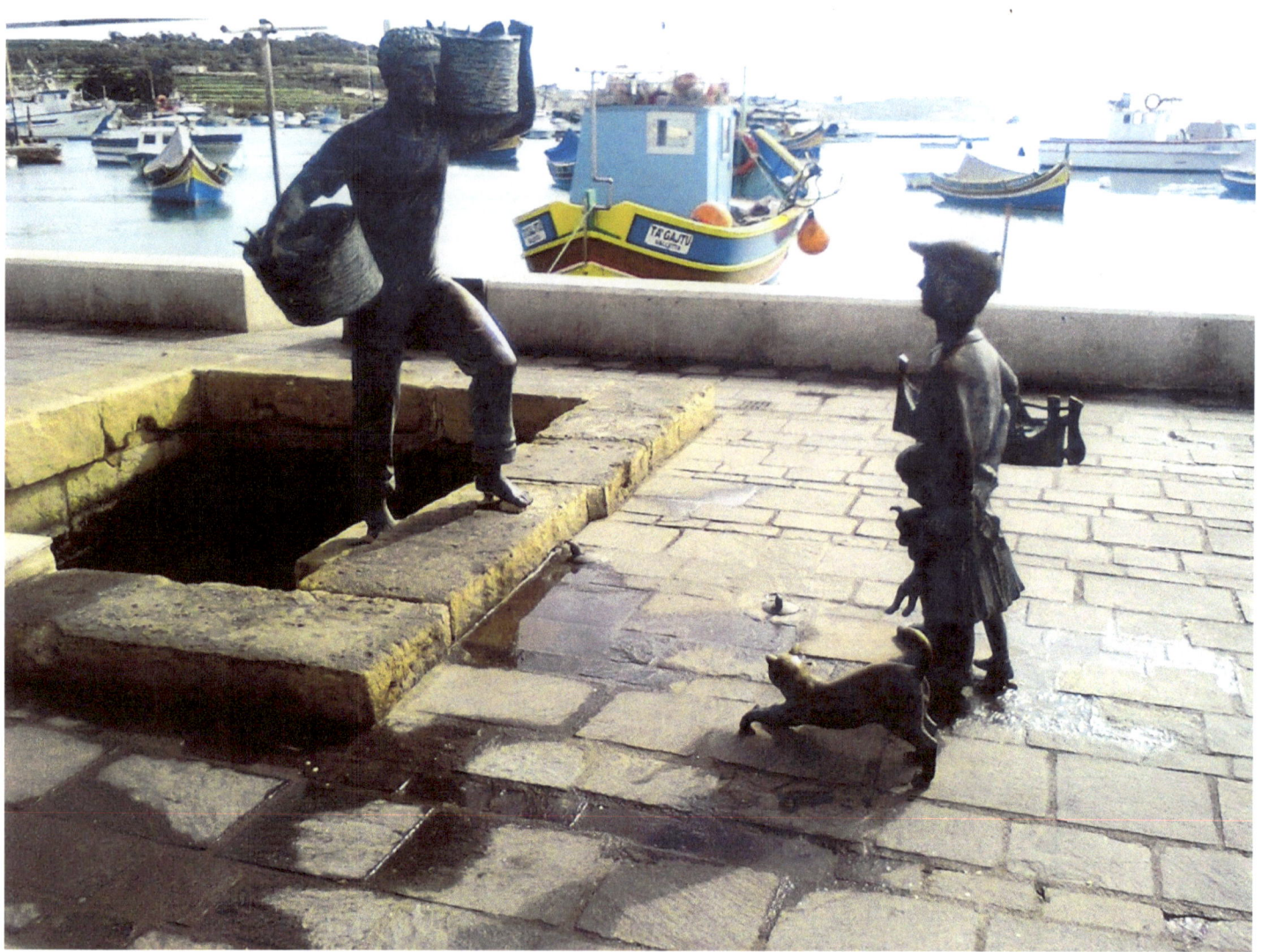
Marsaxlokk

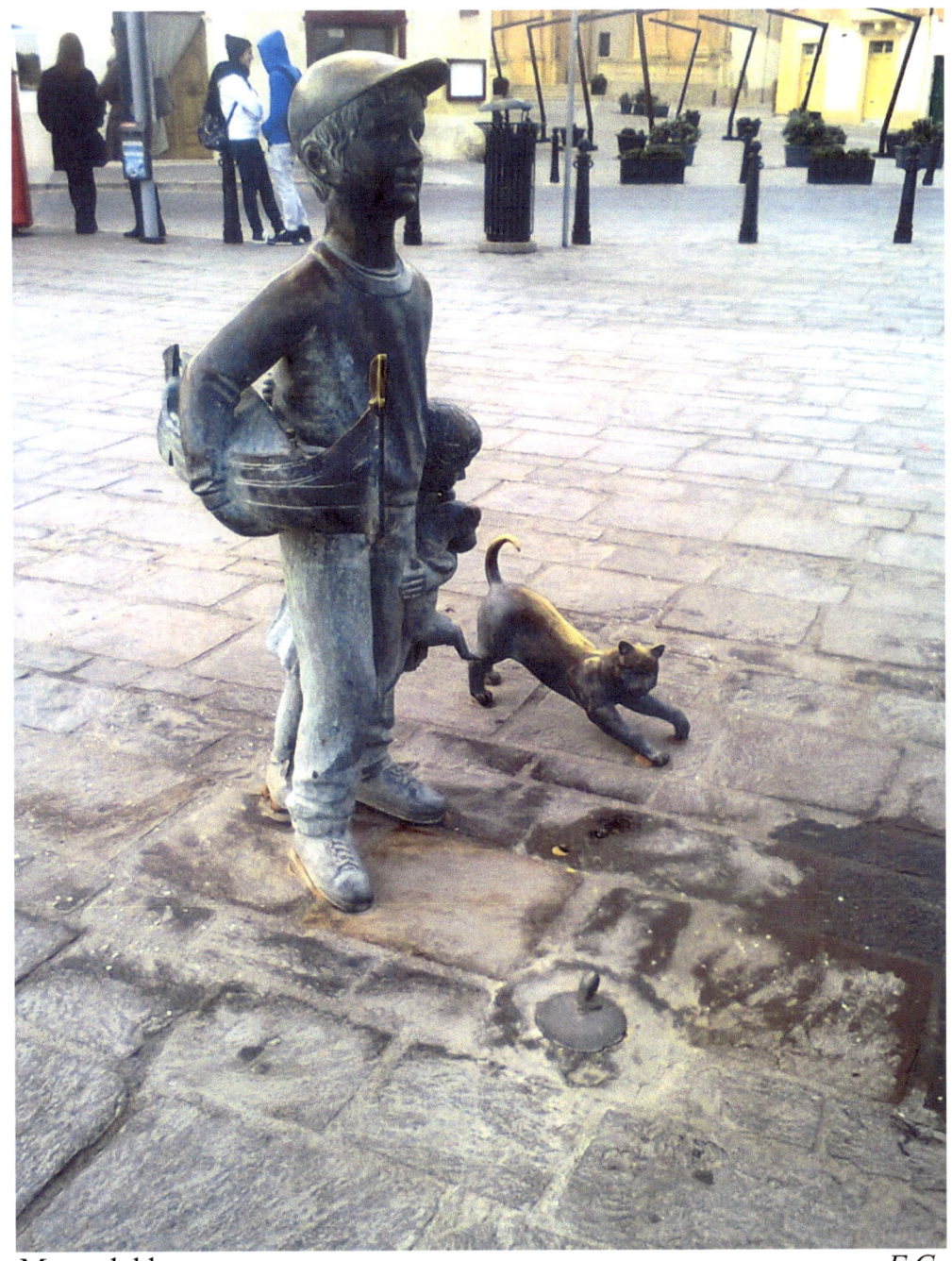

Marsaxlokk F.G.

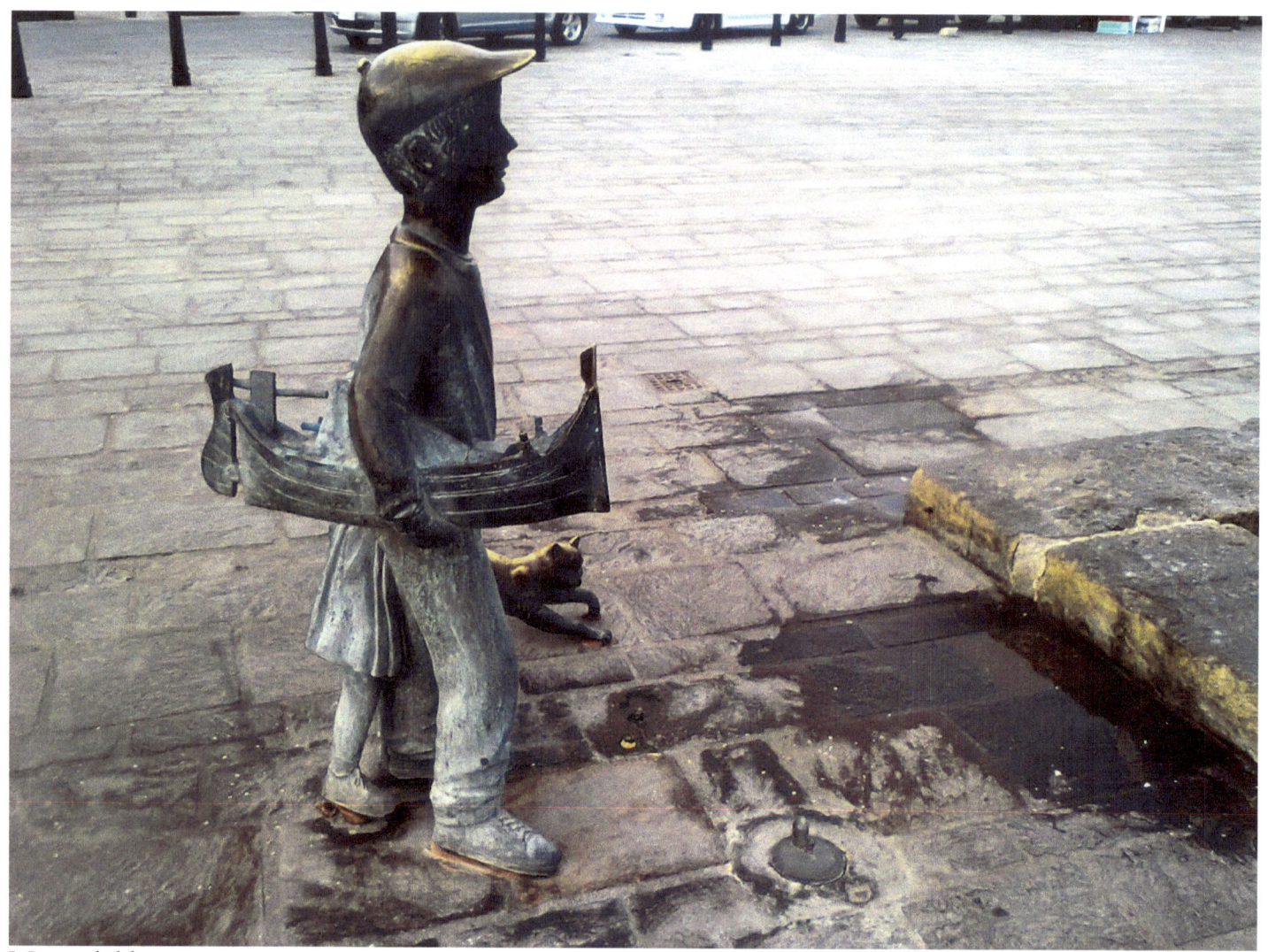

Marsaxlokk *F.G.*

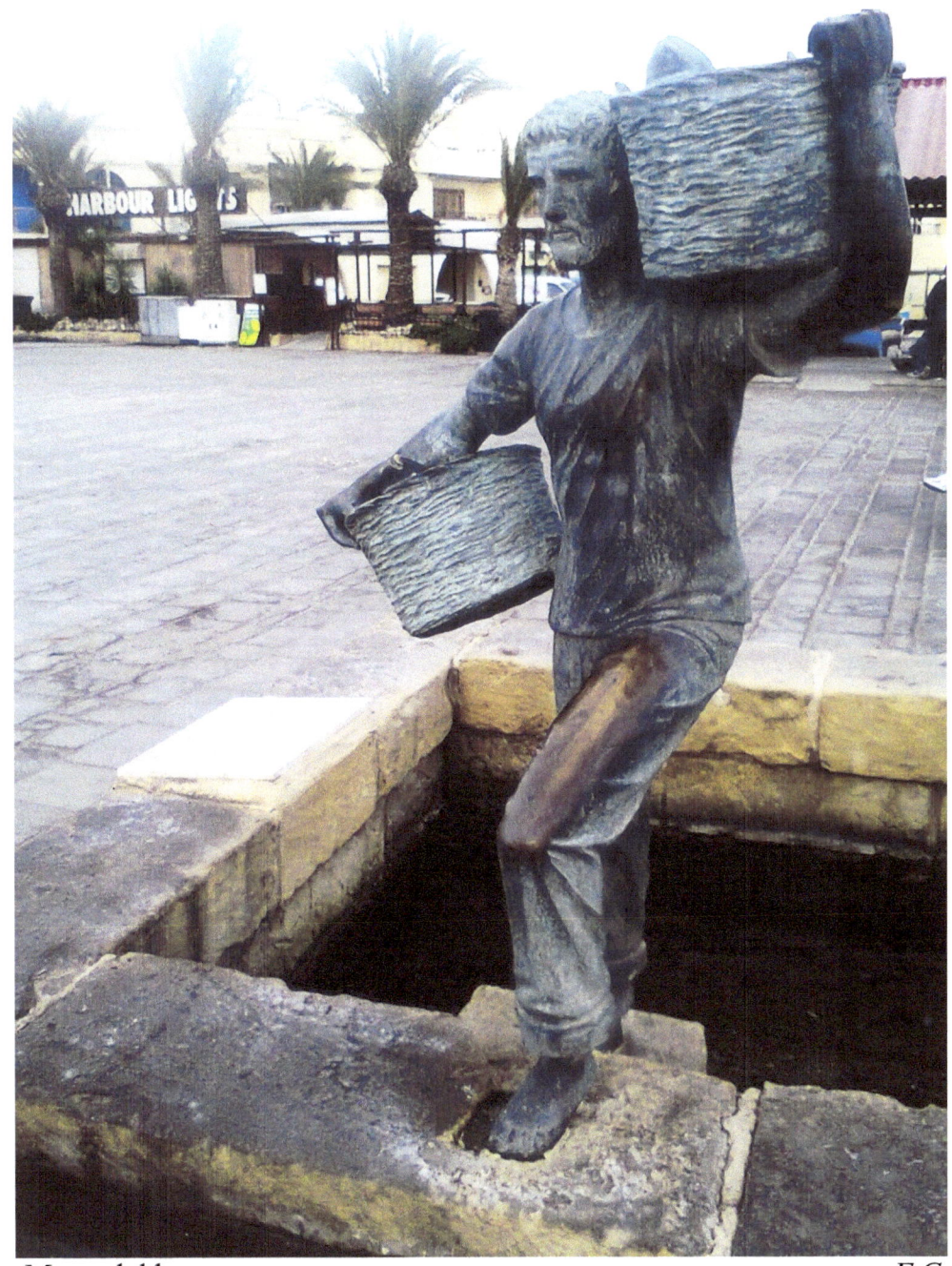

Marsaxlokk F.G.

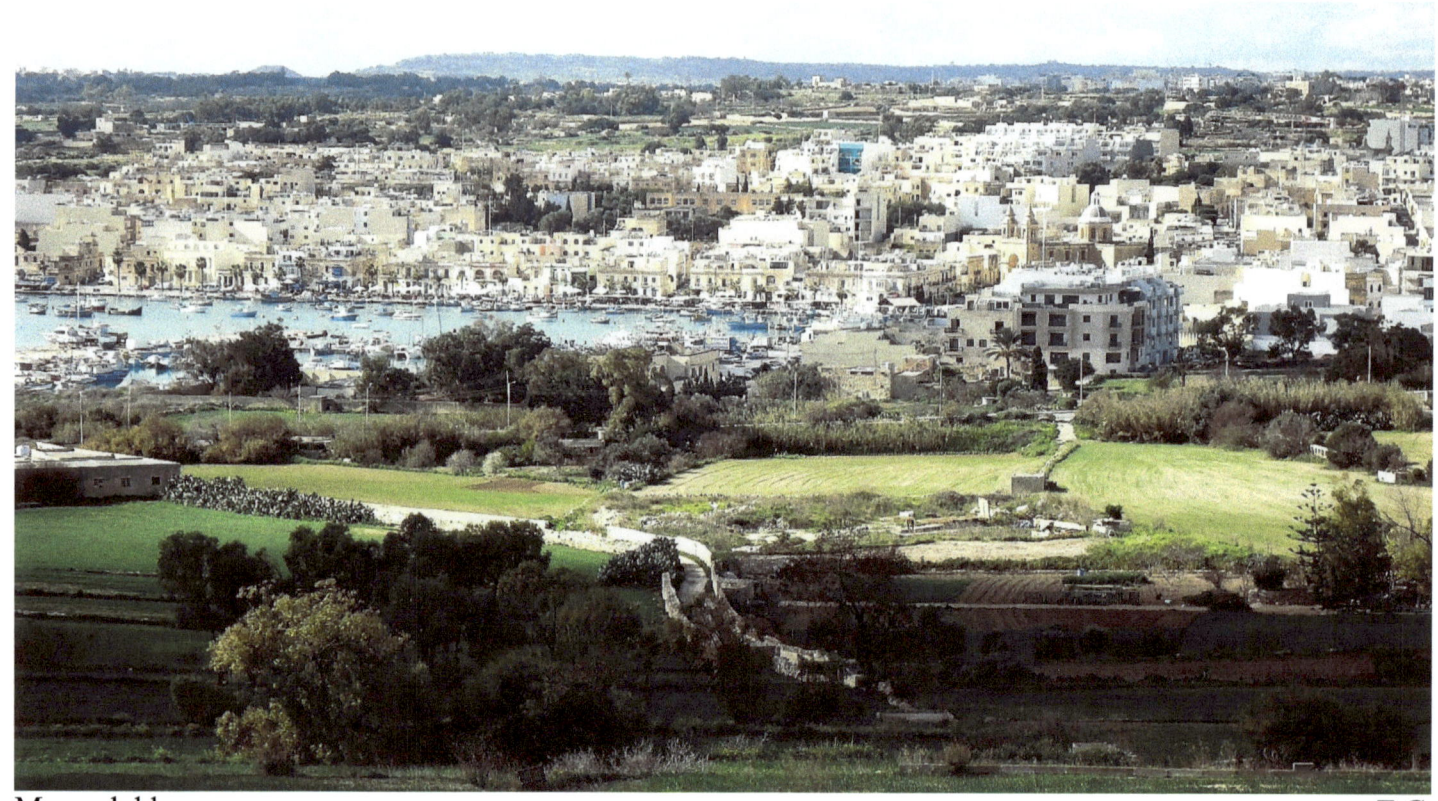
Marsaxlokk	*F.G.*

Qwaresimal, Lenten cookies of the Maltese tradition. Mix together the ground almonds, flour, semolina or whole wheat flour, sugar and spices (cinnamon, nails garafono, cocoa, grated peel of half an orange and lemon), then add the flower water orange, few drops of vanilla essence and enough water to obtain a compact dough. Cut the dough into strips and with your hand form some sausages to get a certain thickness. Arrange the biscuits on a greased baking sheet and place in oven at moderate temperature for 20 minutes. Pour honey on the still warm cookies and sprinkle over pistachios and roasted almonds.

Marsaxlokk — *E.K.*

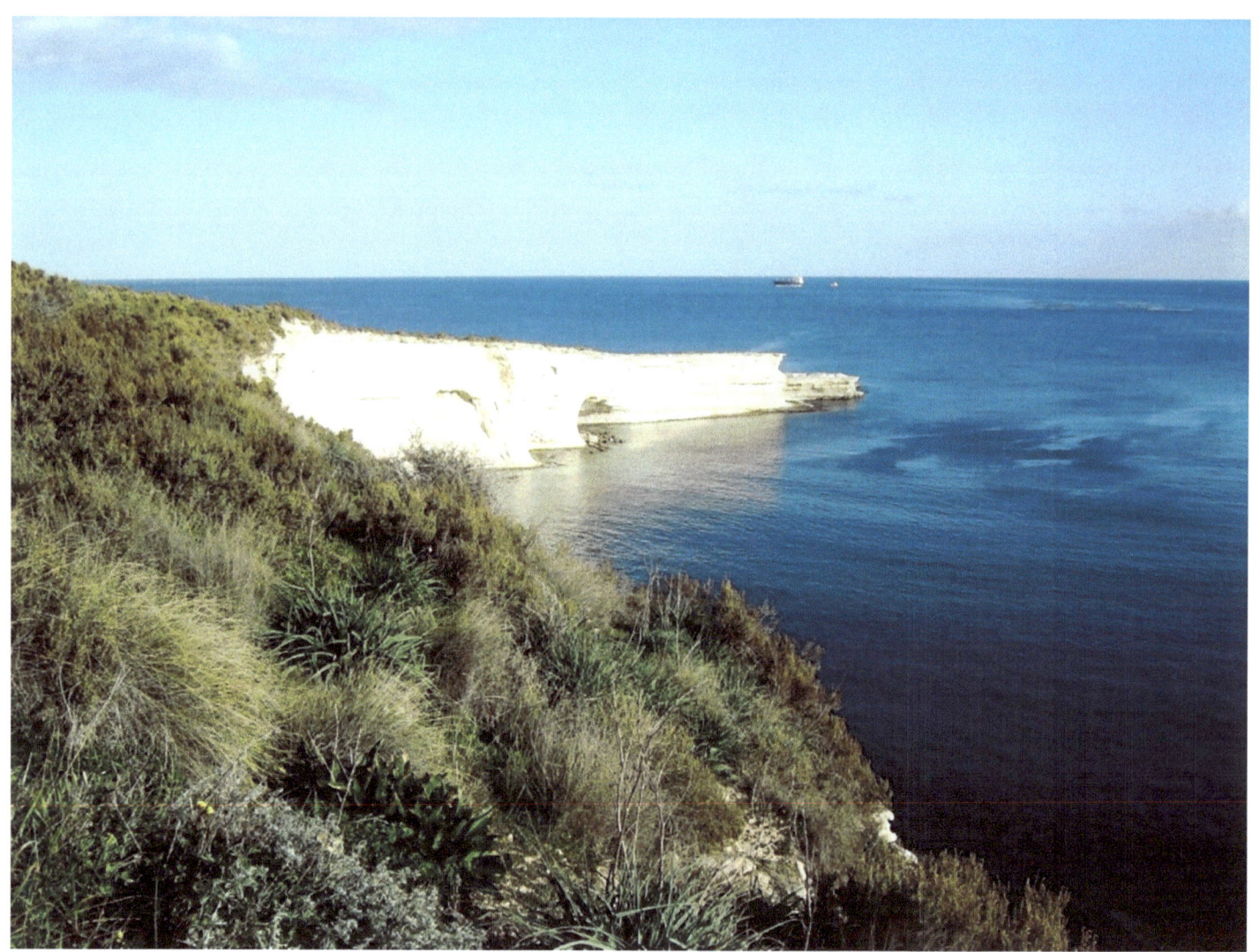
Marsaxlokk F.G.

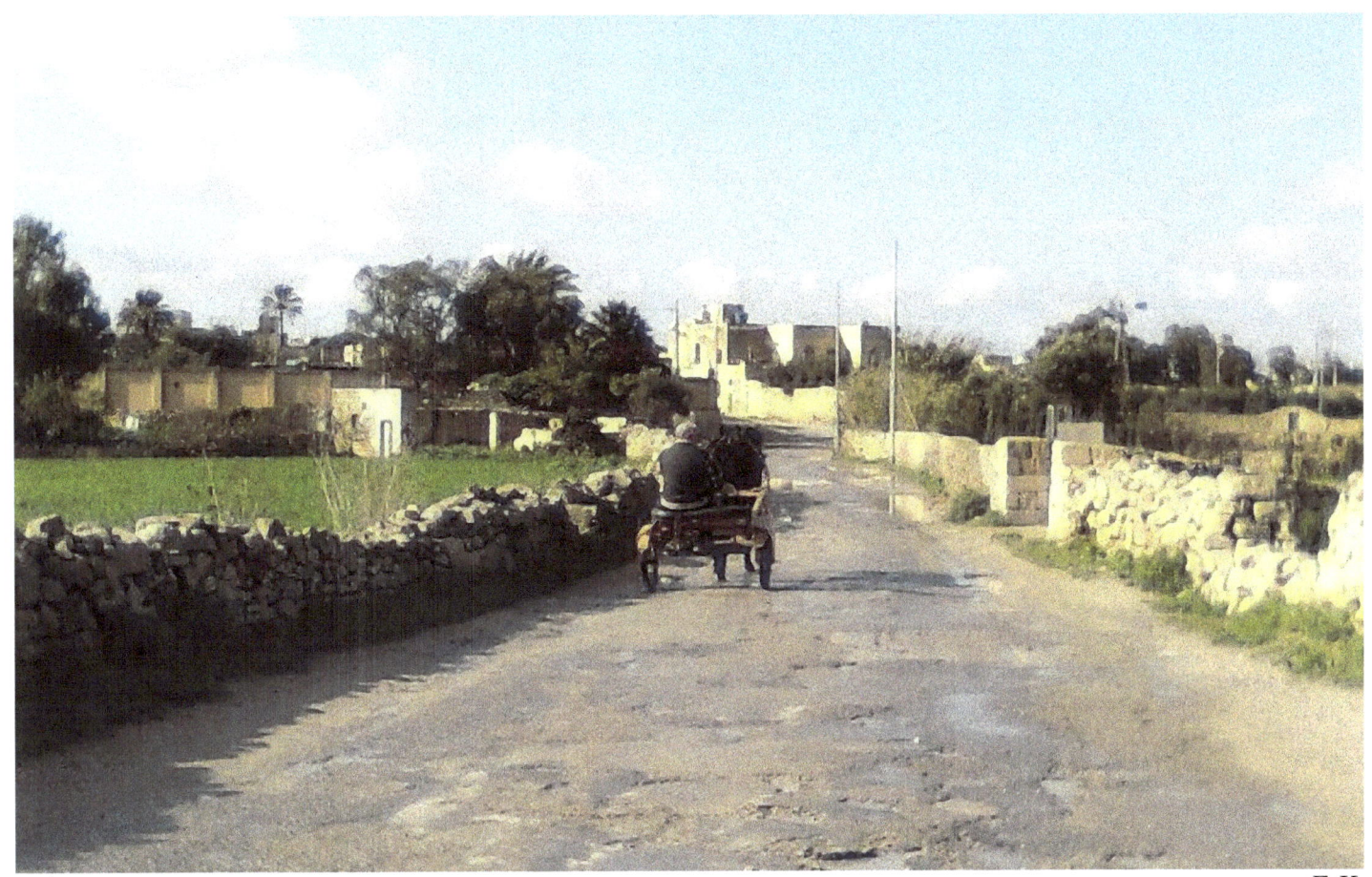
Zejtun *E.K.*

Stuffat tal-Qarnit, braised octopus. Put the octopus in a pot covered with water with bay leaves and rosemary and boil 45 minutes. Then clean it by removing the intestines, the beak and eyes, and cut it into cubes. Beat the tomatoes with the onion, garlic, mint, parsley and a bit of chilli. In another pan, heat the olive oil, add the octopus and brown it 3 minutes. Pour the wine and bring to a boil over high heat, stirring well for another 3 minutes. Now add the chopped tomatoes, a bit of conserve, salt, pepper and paprika to taste. Mix well, cover the pan and cook over low heat for 10 minutes, then add the olives and continue for another 10 minutes. A few minutes before serving, discover the pot and turn the heat to thicken the sauce. Finally completed with mint and parsley.

Marsascala *F.G.*

Sfineg, batter balls fried with a tender stuffed of anchovies or stockfish. Often to make it even more tasty it is accompanied with an excellent pâté of dried tomatoes. Dissolve yeast in half glass of warm water with a pinch of sugar and set aside for 10 minutes. Beat remaining half glass of water in bowl with the flour forming a soft dough. Add the very small pieces of anchovies and knead the dough for about 10 minutes by hand and 5 minutes in a mixer with a dough hook. Put the dough in greased bowl and turn to coat. Cover and let rise until doubled. Break some pieces of dough the size of a golf ball and fry until golden brown. Drain on brown paper or paper towels and dust with confectioner sugar.

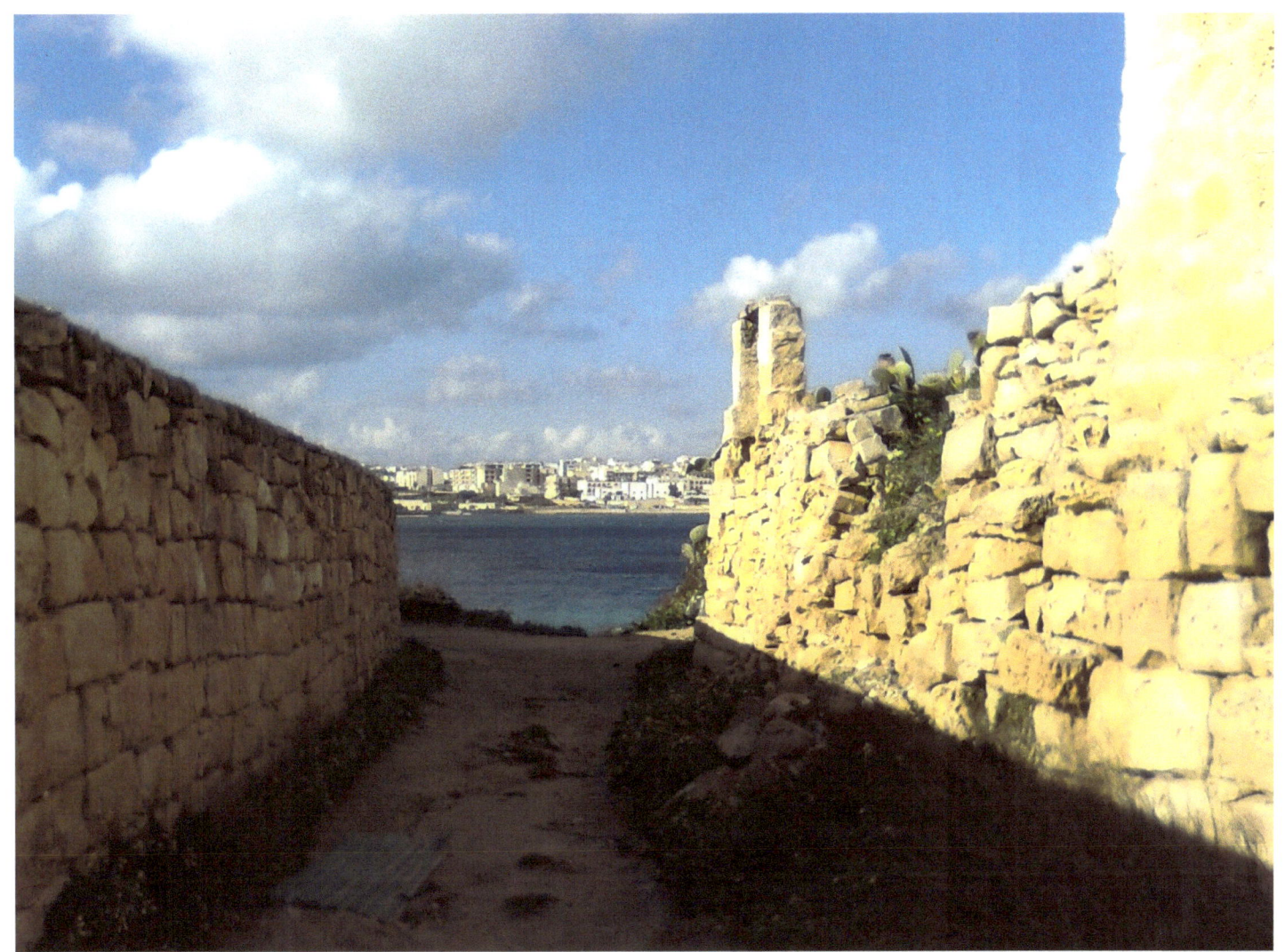

Marsascala — *E.K.*

L.S.

Mellieha *E.K.*

Imqarrun il-forn, bake macaroni in the Maltese way. Saute the onion in olive oil over medium heat until golden brown, then add the garlic, being careful not to burn it. Add the ground pork and beef, bacon and chicken livers, salt and pepper, stirring often for about 15 minutes, then conserve and chopped tomato. Bake for 30 minutes covered and uncovered for another 30 minutes, adding a little of water at need. Meanwhile, cook the pasta in salted water. Drain and pour it into a large bowl with the sauce. In a separate bowl beat the eggs with the Parmesan cheese and incorporate them into the dough. Grease a large baking sheet and fill it with the dough. Sprinkle with grated cheese and bake in oven for 45 minutes until the cheese has melted, golden and crispy. When cooked, remove from oven and let cool a few minutes. Cut and serve!

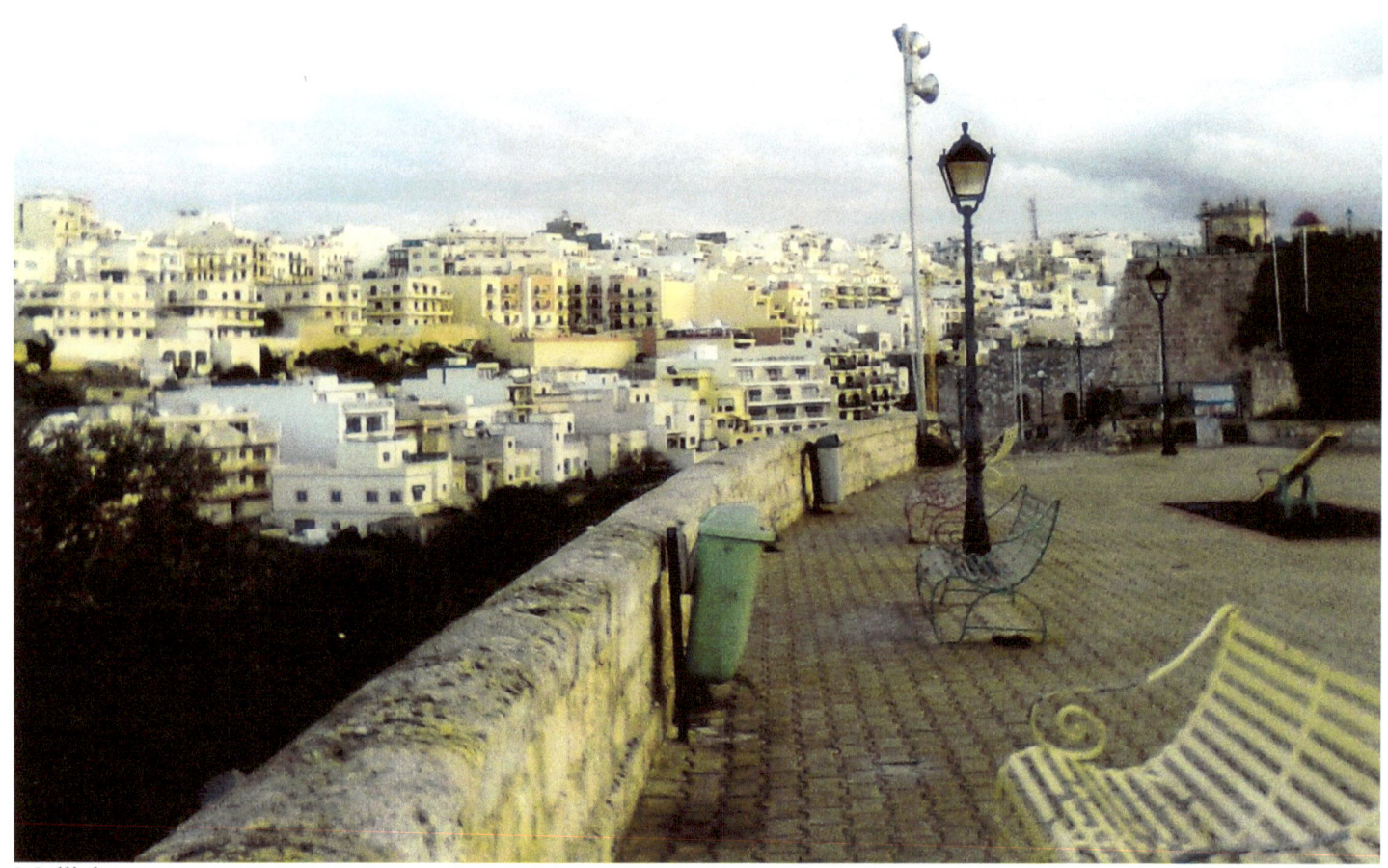
Mellieha *E.K.*

Bragioli, beef chops rolled around a savoury filling of breadcrumbs, bacon and eggs. Beat the slices of veal or pork. Chop bacon, cheese, garlic, capers, parsley with breadcrumbs. Sprinkle the slices with this mixture and add half a boiled egg. Close your rolls with toothpicks and bake in a pan with olive oil and bay leaf. In the same pan, cook the onion and carrot, also adding a bit of red wine. Put the rolls in a baking pan with the sauce and bake in a 180 degree oven.

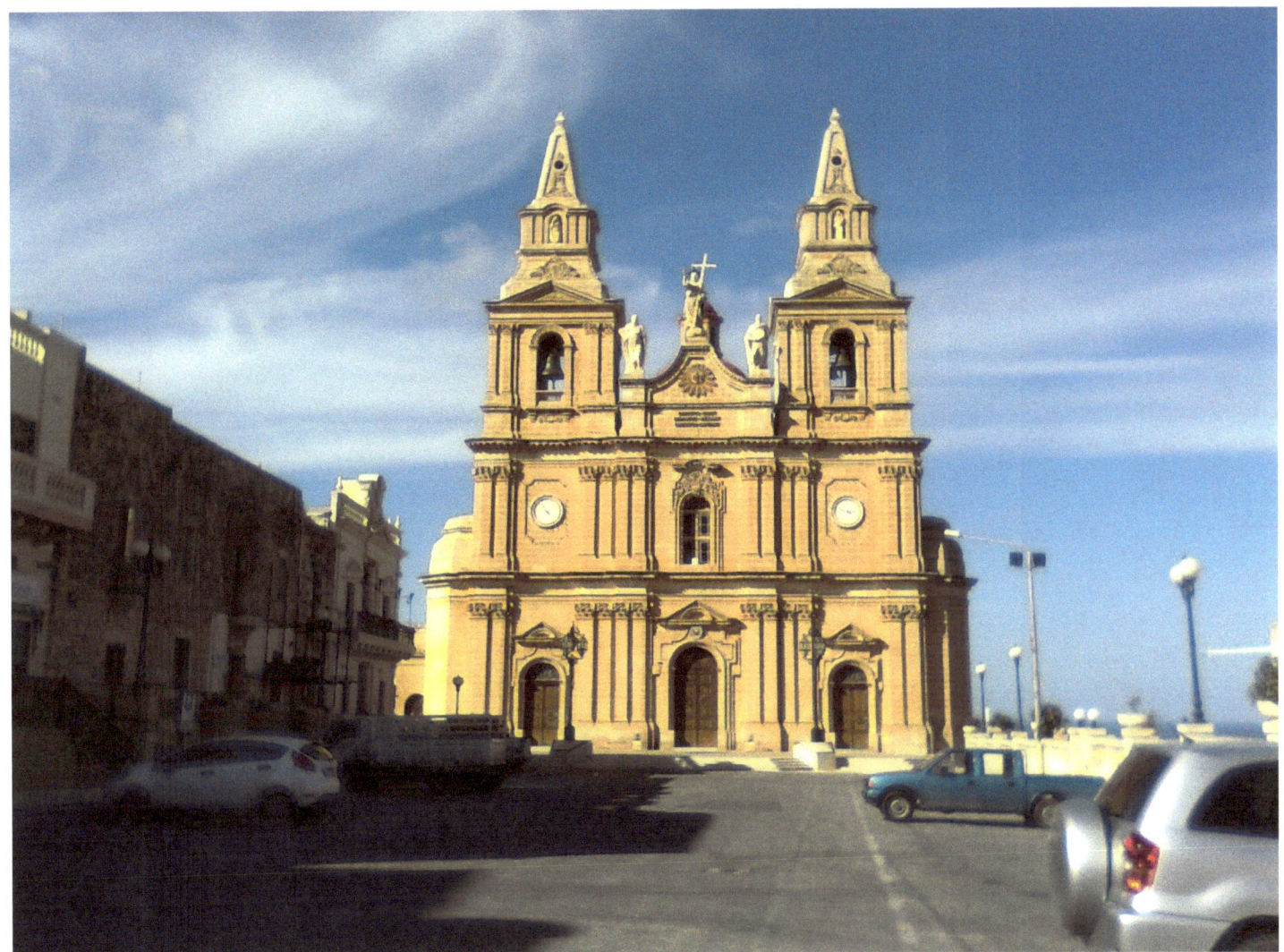

Mellieha *E.K.*

Mugiarro F.G.

Mugiarro F.G.

Mugiarro - Riviera Martinique *F.G.*

Islands of St. Paul *F.G.*